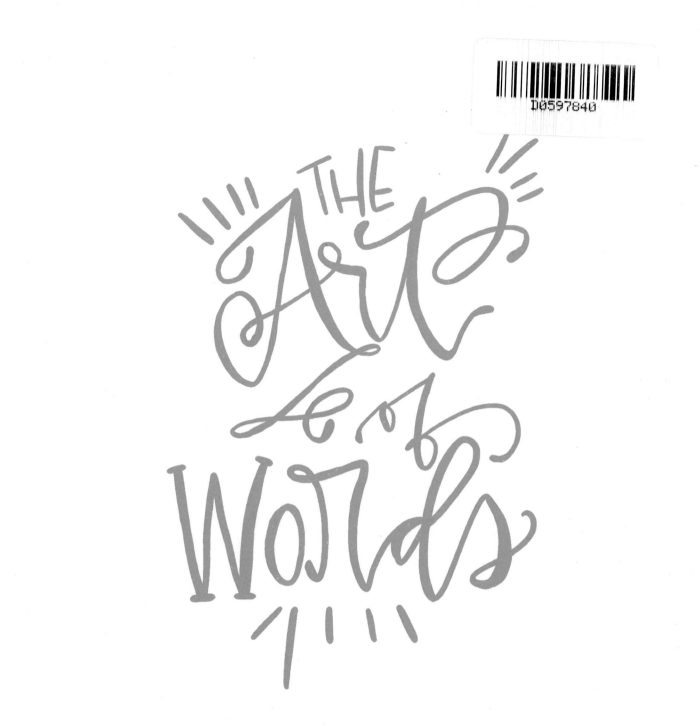

THE Art of Words

VALERIE WIENERS

PASSIO

Contents

Foreword . v
Introduction . 1

THE BASICS

Parts of a Letter . 4
Terms You May Not Know . 5
Supplies . 6

CREATE CALLIGRAPHY WITH ANY PEN

Fake Calligraphy . 17
Calligraphy With Any Type of Letter . 19

YAY FOR FUN LETTERS

Tall Alphabet . 24
Upper and Lower Mix-Up . 27
Cursive Mix . 30
Original Capital and Lower . 33
Hollow Letters . 36

MAKING IT ALL PRETTY

Arrows . 41
Floral Decorations and Wreaths . 42
Flourishes . 44

MIXING STYLES AND LETTERS

Serif and Sans Serif . 52
Thin, Bold, and Script Styles . 54
Lettering Warm-Up . 61

LETTERING PROJECTS TO PRACTICE YOUR SKILLS

Hand-Lettered Tags . 66
Watercolor Hand-Lettered Tags . 68
Wrapping Paper . 70
Doodled and Painted Letter . 72
Wooden Sign . 75
Gouache-Painted Quote . 77
Painted Canvas . 79
Hand-Lettered Cards . 83
Hand-Lettered Envelopes . 85

Scrapbook Page . 87

Chalkboards . 89

Bible Journaling . 92

ARTWORK TO INSPIRE

Color and Letter Tags . 99

Bookmarks . 100

Inspirational Cards . 102

Mirror Cards . 105

Coloring Pages . 108

Lettering Templates . 114

About the Author . 121

Foreword

I frequently get asked how I learned hand lettering. To be honest, I am still learning, but to grow in my skills, I look to those who inspire me and learn from them! Valerie is someone I look to not only for inspiration but also for instruction. From the moment I started following her on Instagram a couple of years ago, I fell in love with her unique style, but I also fell in love with how she reaches out and helps anyone who asks. Valerie has a grace about her that allows her to share the insight and vision she has cultivated as an artist, and that isn't something you find often in the online community!

Can I be perfectly honest with you? I am a lettering dropout. It's true! A couple of years ago I signed up for a calligraphy class near my home, super excited to learn new skills and improve my wonky letters. As I showed up to class and sat down, they had us practice on some simple shapes. The teacher came over to watch, and as she looked over my shoulder, she asked, "Are you left-handed?" I was quickly kicked out after that! What I love about Valerie is: 1) she isn't going to kick you out of class, and 2) she keeps it super simple by starting from the very basics and then inspiring you to go off script and really find your own style.

As the lettering community has grown and expanded, the people who really stick out and inspire me are those who have discovered their own style, their own flair, and their own message. When I think about these characteristics, Valerie is the first person to come to mind. Her style can be spotted from across the room; it screams of inspiration and color—big, beautiful, whimsical flowers combined with beautiful words form meaningful messages. Her style is clearly her own, and she pairs it with heartfelt and inspirational messages—something only she can do in this way. As you work through this book, you will find that not only does Valerie give you the tools to form the foundation of letters and a basic style, but also she really mentors you to just have fun in the process and find a style that *screams* you!

I love Bible journaling, and I am a visual learner, so I love books that inspire me to work right inside them and that leave space to play, learn, and document my process. That is exactly what this books does! When you are done, you should be able to look back through the book and see your progress through the pages as you painted, colored, and doodled your way through the lessons.

Enjoy this journey with Valerie, and make sure you share your work and progress! I can't wait to see what you are up to!

xox, Shanna Noel
Owner, Illustrated Faith
Founder, Bible Journaling Community

Introduction

Hello, and thank you so much for purchasing this book! I have had a love of letters and drawing since I was a little kid. As I got older, my love of drawing letters grew. Letters are everywhere, and I hope this book will help you see the design in every little thing and find inspiration everywhere you look. As you drive by the movie theater, visit the mall, sit at the local coffee shop, or read your magazine, doodle and jot down the letters and designs you love. That's what I did for years.

Until seven years ago my life was a bit chaotic, but I always had art as something to help me relax and find peace and stability. If you ever feel overwhelmed, grab a pencil and doodle for ten minutes, and I bet you will feel better.

I create art for a living, and my goal is to create with inspiration from the Creator and to point people back to Jesus. With this book my hope is that you will feel encouraged to begin and to try hard. You can do this—practice makes you better. Just remember that. You will never be perfect—neither will I—but we can be creative while finding styles that work best for us. Be encouraged, and don't give up!

You've got this.

—Valerie

THE Basics

Parts of a Letter

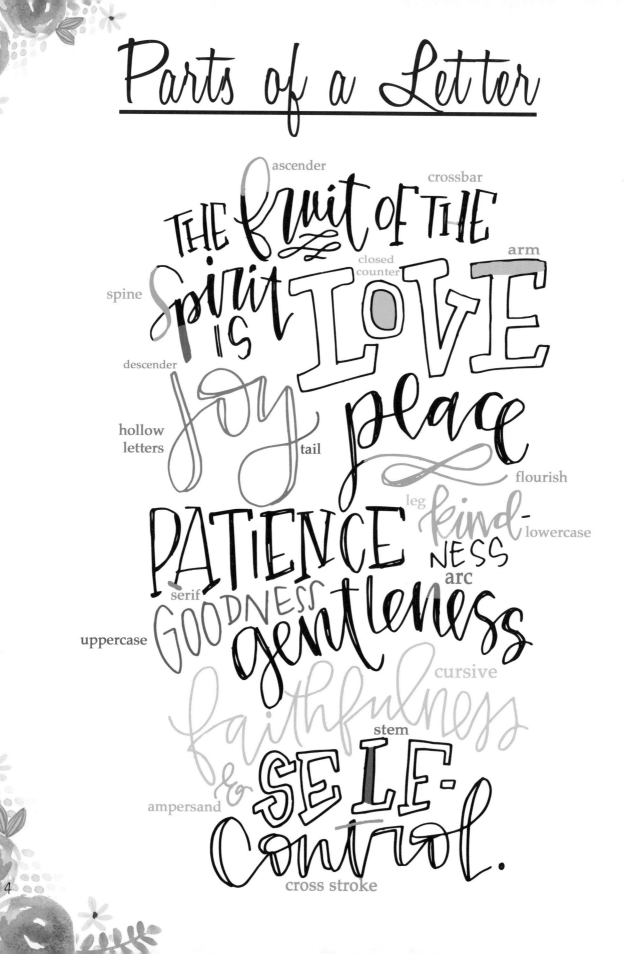

ascender

crossbar

THE fruit of the

closed counter

arm

spine

spirit is LOVE

descender

Joy peace

hollow letters

tail

flourish

leg

PATIENCE kind-ness

lowercase

arc

serif

GOODNESS gentleness

uppercase

cursive

faithfulness

stem

ampersand

SELF-Control.

cross stroke

Terms You May Not Know

Calligraphy—the art of making decorative handwritten lettering

Lettering—the art of drawing letters—this book is all about drawing letters.

Serif—the small details at the ends of letters

Sans serif—literally means "without serif"

Script lettering—letters joined together that look like handwriting but are drawn

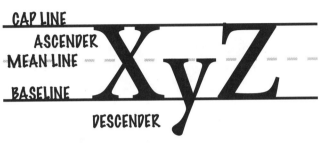

Cap line—the top line where the letter reaches

Mean line—the middle line

Baseline—the writing line, where each letter rests

Ascender—the part of the letter that goes higher than the mean line

Descender—the part of the letter that is below the baseline

Upstroke—the stroke of the letter that is drawn in an upward motion, bottom to top

Downstroke—the stroke of the letter that is drawn in a downward motion, top to bottom

Flourishes—the fun and whimsical decorations that may be attached to letters or stand alone

Gouache—opaque (nontransparent) watercolor

Acrylic stamp—a stamp that is peeled off a backing and placed on a block for stamping

Acrylic paint—fast-drying paint that is water-resistant when dry

Watercolor paint—paint pigment that becomes "alive" when water is added

Water-brush pen—a pen that holds water in its barrel and lets down water when squeezed

Archival Ink pad—a permanent ink pad that is water-resistant

Brush Tip—a pen used for creating calligraphy

Chalk pen—washable color used on chalkboards

Washi tape—decorative paper tape that is removable and adds a pop to anything

Warm colors—red, orange, and yellow

Cool colors—green, blue, and purple

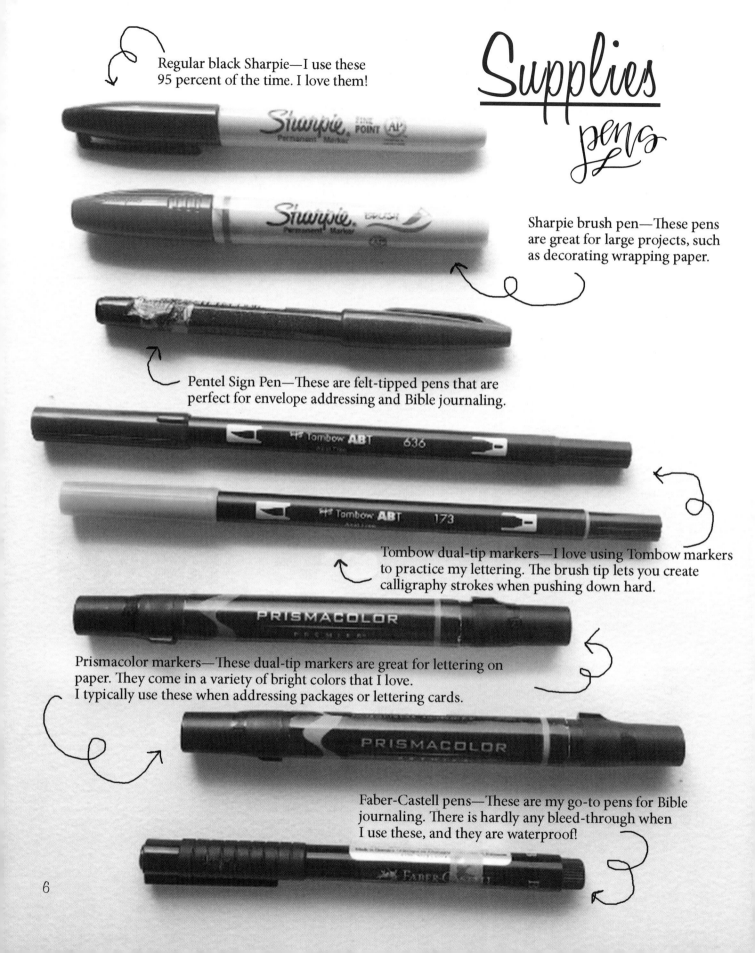

Regular black Sharpie—I use these 95 percent of the time. I love them!

Supplies
pens

Sharpie brush pen—These pens are great for large projects, such as decorating wrapping paper.

Pentel Sign Pen—These are felt-tipped pens that are perfect for envelope addressing and Bible journaling.

Tombow dual-tip markers—I love using Tombow markers to practice my lettering. The brush tip lets you create calligraphy strokes when pushing down hard.

Prismacolor markers—These dual-tip markers are great for lettering on paper. They come in a variety of bright colors that I love. I typically use these when addressing packages or lettering cards.

Faber-Castell pens—These are my go-to pens for Bible journaling. There is hardly any bleed-through when I use these, and they are waterproof!

There are so many pens out there to choose from. Getting the perfect pen is all about how you feel about it. Many people will say that they love a certain art supply, and you try it out, and it just doesn't work the same way for you. Every letterer has her favorite, but you don't have to spend a ton of money. The tool doesn't make the artist great; the artist makes the tool great. I love using Sharpies for practicing and lettering in my sketchbooks. Sharpies are inexpensive, and you can create the fake calligraphy style that is loved by so many because they can be used on so many things!

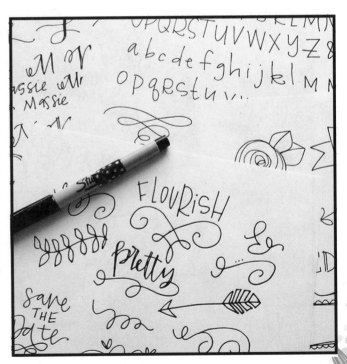

Faber-Castell

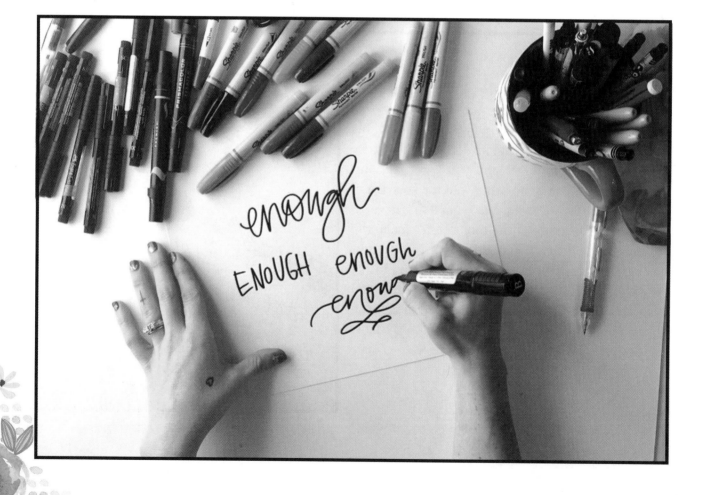

Faber-Castell pens are some of my favorites. They are waterproof, they are good for journaling in my Bible, and they have a variety of tip sizes. Each one has a specific purpose in my art. They make super fine points, so I can doodle really small and make tiny details. They also make really big brush tips that are good when I want to make a video or letter a box. These pens are pricier and cost about fifteen dollars for a pack, but in my opinion they are totally worth it.

Great Pens at Every Price

Sharpies are inexpensive and the greatest marker I have found. I love these for doodling, creating prints, and addressing envelopes!

Paper Mate Flair is an awesome and affordable felt-tip pen. It is great for doodling in a sketchbook, making tags, and creating fake calligraphy.

Stabilo has great pens that are perfect for Bible journaling. They don't bleed through, and they come in a variety of colors!

Tombow has a dual-brush pen that is a little more expensive but is worth the money. There is a fine tip and a brush tip. The brush tip is awesome for lettering and will give you that calligraphy look you want!

Pigma Micron pens are pricier, but they are great for Bible journaling because they don't bleed and are waterproof. These pens come in super fine and go all the way to a brush pen. They are great because of their variety of sizes.

Faber-Castell pens are a bit more expensive and are comparable to Pigma Micron pens. However, I like Faber-Castell's brush pen more because it has more control and the tip is finer. I also like that the cap stays on well, unlike the Pigma Micron pens.

Watercolors

Watercolors are great for doodling, practicing, lettering, and Bible journaling. I take watercolors when I travel because they are small and can go anywhere. The brush inside the set may not be great, but you can purchase a brush to go with it, and brushes are relatively inexpensive as well. I recommend Artist's Loft and Master's Touch watercolors; each set is under ten dollars, and both have good color variety.

Water-brush pens are great for using watercolors on the go. They are great for kids in the car or painting at church without a mess. The pens work when you place water inside the barrel and squeeze. This lets you control when and how much water comes out.

Liquid watercolors are great for lettering. They are transparent when they stand alone with water, but they can be opaque if you add white liquid watercolor to the color. Dr. Ph. Martin's watercolors are my favorite, but they are not inexpensive. They have a variety of colors, and each one delivers.

Liquid
Watercolors

Acrylic Stamps

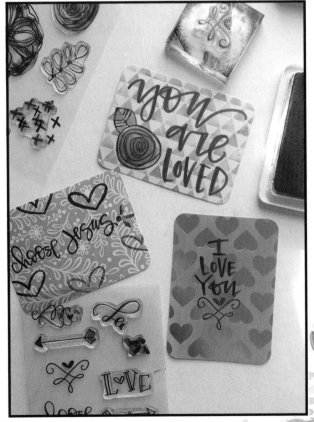

PAPER

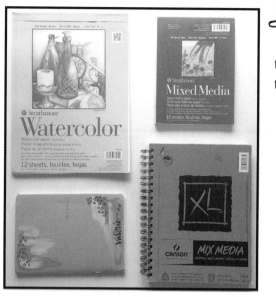

There are many types of paper out there for all sorts of things, but these four are my favorites, and they are all relatively inexpensive.

- The yellow Strathmore watercolor paper is a cold-pressed paper, which means that there is a lot of bump to the paper. It holds colors well and gives it a nice texture. There is also hot-pressed, which is a smoother, more finished product.

- The brown pad is a mixed-media book. It allows you to use anything you want on it, including markers, watercolors, acrylic paint, ink, pencil, or gouache. This is your go-to paper if you only want to buy one pad and get the most use out of it. It is bound at the top for easy tear-out.

- The next book is a Fabriano green sketchbook. This is my favorite sketchbook for on the go. It holds up well to watercolors and markers, but there is some bleed-through because it is a sketchbook meant for pencils and pens. This is the perfect size to carry around or take on trips.

- The blue pad is also a mixed-media pad, but it is spiral-bound at the side for easy flipping. It is my favorite pad.

Paper, similar to pens, is all about personal preference and budget. You can spend a little, as I do, or a lot. Lettering doesn't require a large budget, though. Just grab a piece of notebook paper or computer paper and a number 2 pencil, and you can get right to work. My favorite supplies are often the least expensive. Remember, the tools don't make the letterer; the letterer makes the tools!

Use the space below to write in the types of paper you have tried.

MY favorite SUPPLIES

Use this space to keep track of all the fun supplies you come across.

Use this page to try out your new pens and watercolors.

Once you've ACCEPTED your flaws NO ONE can use them Against you.

15

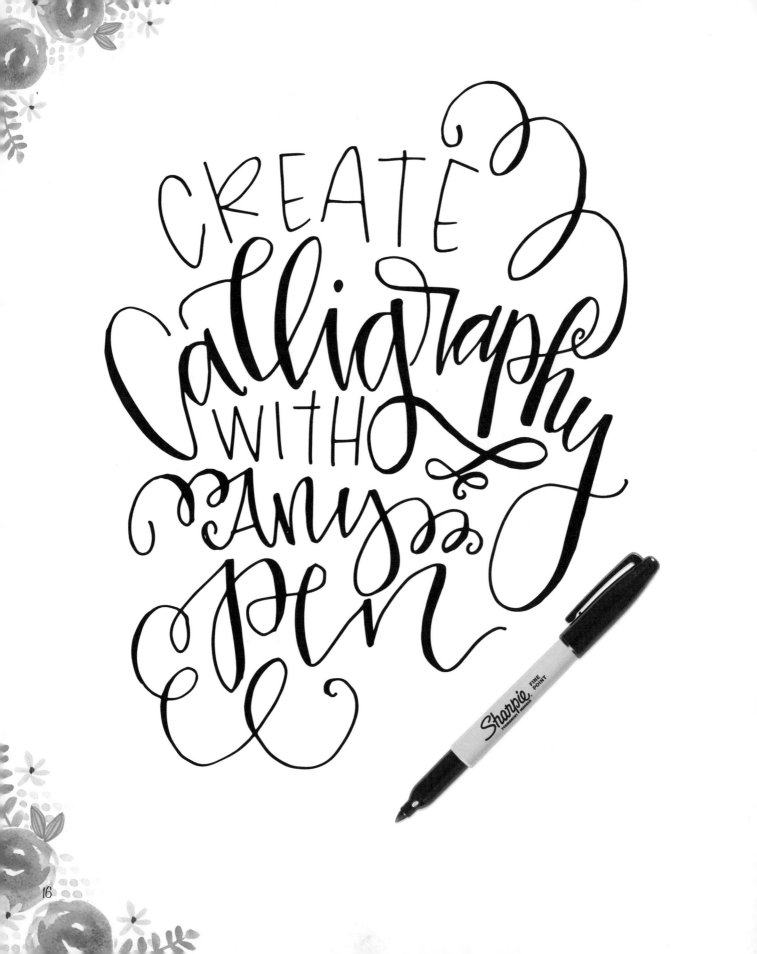

CREATE calligraphy WITH ANY PEN

Fake Calligraphy

Step 1: Grab your favorite pencil and your favorite marker or pen. Keep in mind that creating calligraphy is less about the pen and more about the skill.

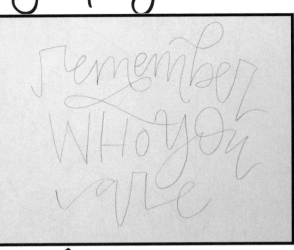

Step 2: Draw your design in pencil. It doesn't have to be anywhere near perfect because you are going to make changes in the next step. This is just the "mapping out" stage. Think of which words need to be larger and which need to be smaller.

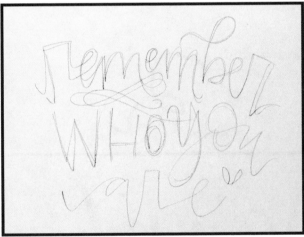

Step 3: This is the refining stage, so decide which details need to be changed and which ones are good. In this picture the flourish under the *m* in *remember* went too far and touched the *y* in the word *you*. Everything else looked OK to me, so I left everything else the same and moved on to the next step.

Step 4: Grab your favorite marker—mine is a brand-new Sharpie straight from the box—and trace over the words. Be careful to stay on your *good* lines. The next step will make it look like calligraphy!

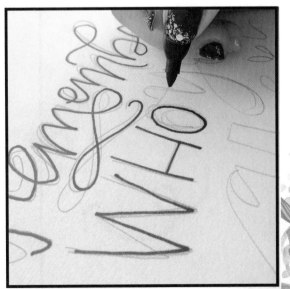

17

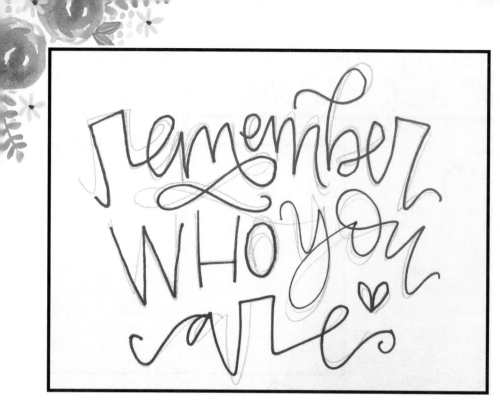

This is the final outline of the Sharpie over pencil from step 4.

Step 5: Double all downstrokes for every word.

Step 6: Color in all double lines. Hooray! You just created fake calligraphy!

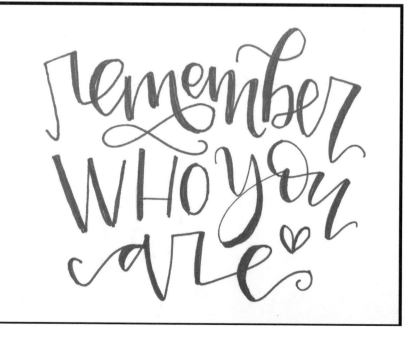

Calligraphy With Any Type of Letter

Step 1: Grab a pencil and pen.

Step 2: Write out your words in pencil.

Step 3: Refine the drawing, and correct any details.

Step 4: Go over the whole thing with pen.

Step 5: Double the lines on the downstrokes.

Step 6: Fill in the lines!

use ANY pen to Create fake CALLIGRAPHY

You can create fake calligraphy on cursive letters or uppercase letters!

19

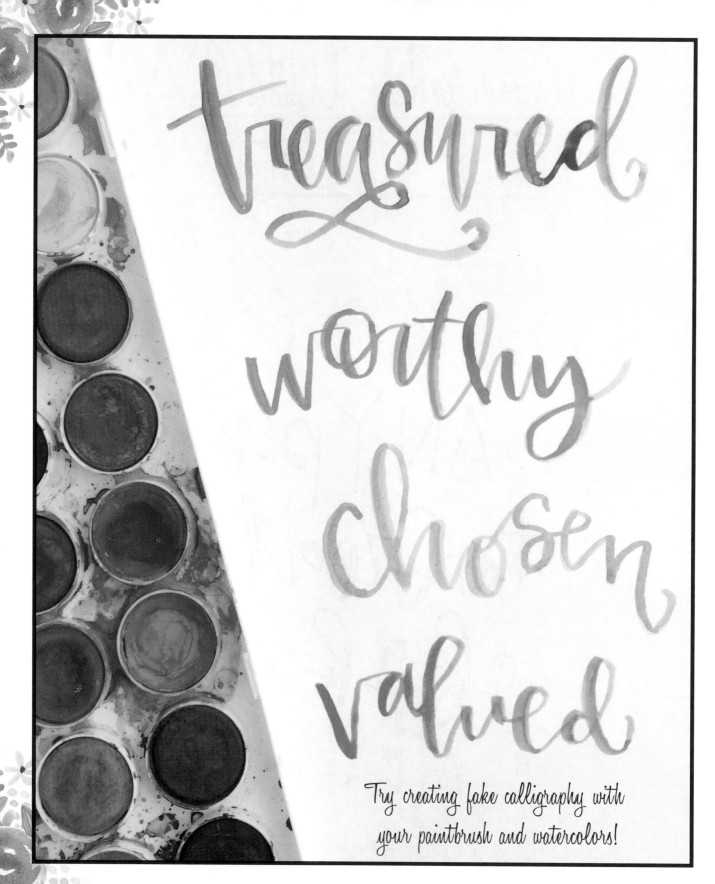

treasured

worthy

chosen

valued

Try creating fake calligraphy with your paintbrush and watercolors!

fake
CALLIGRAPHY

Use this page to practice!

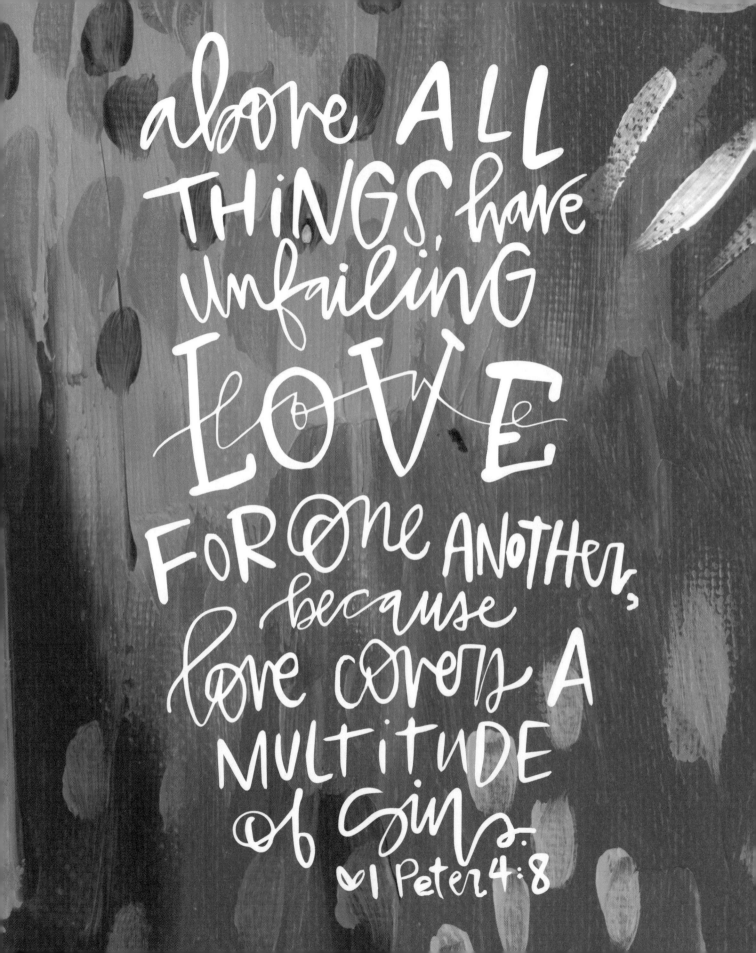

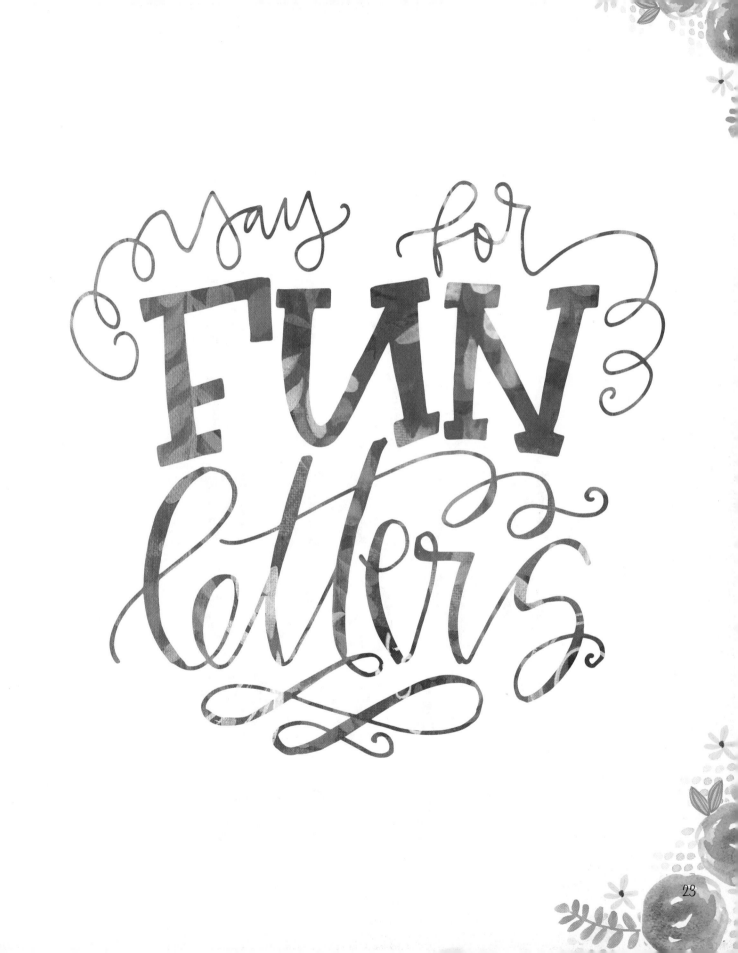

Yay for FUN letters

TALL
alphabet

A B C D E

F G H I J

K L M N

O P Q R S

T U V W

X Y Z &

24

TALL
alphabet

Use this page to practice drawing over the gray lines. Remember, lettering is more drawing letters and less handwriting.

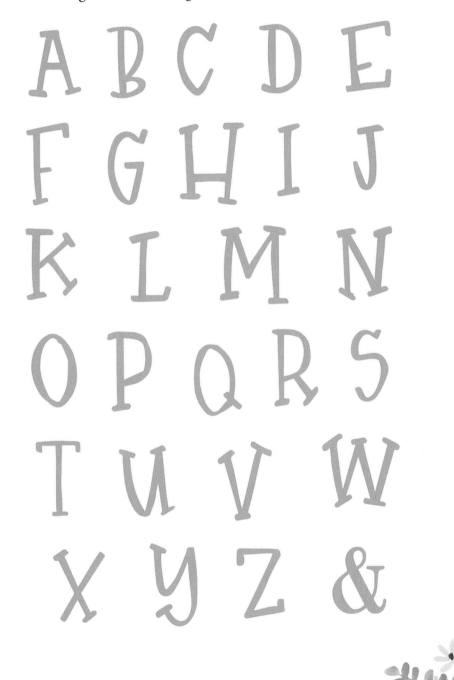

practice MAKES you better

People always say, "Practice makes perfect," but that's not the case in lettering. You will never be perfect, but you can be better! Practice drawing the Tall Alphabet. Mix up where your crossbars and cross strokes hit the lines.

LETTER

A B C D E
F G H I J
K L M N
O P Q R S
T U V W
X Y Z &

UPPER
& lower
Mix-up

A B C D E F G

H I J K L M N

O P Q R S T U

V W X Y Z & &

abcdefghijklm

nopqrstuvwxyz

27

UPPER & lower Mix-up

Use this page to trace the gray lines. Notice how each letter feels as you draw it. Use a pencil, pen, or Sharpie, and make it your own. You can add extra swirls to the letters. Try not to lift the pen when practicing the lowercase cursive letters except when there is a break. It's all about letting your letters flow.

A B C D E F G

H I J K L M N

O P Q R S T U

V W X Y Z & &

a b c d e f g h i j k l m

n o p q r s t u v w x y z

practice MAKES you better

Use this page to practice your Upper and Lower Mix-Up. Mix uppers and lowers to create your words, and then practice using a brush-tip marker, a water pen, or any other fun supplies you have! Remember, practice makes you better.

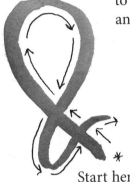

Start here.

A B C D E F G
H I J K L M N
O P Q R S T U
V W X Y Z & &

abcdefghijklm
nopqrstuvwxyz

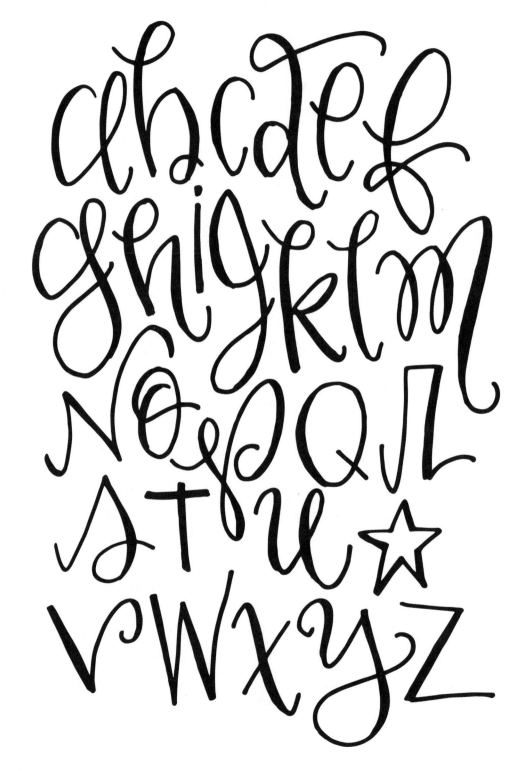

Inspiration

Use these examples as inspiration to create your
own cursive mix lettering combinations.

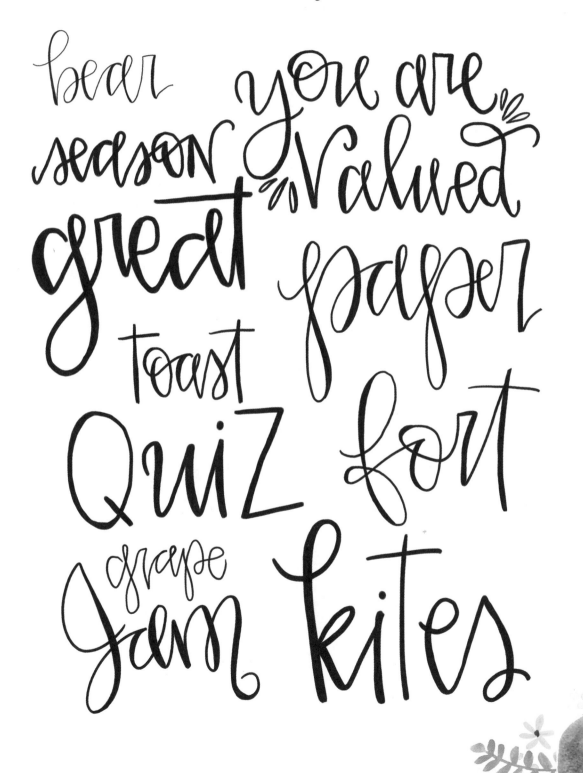

bear
season
great
toast
Quiz
grape
Jam

you are
Valued
paper
fort
kites

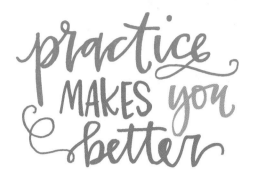

Use this page to practice the Cursive Mix.

Original Capital and Lower

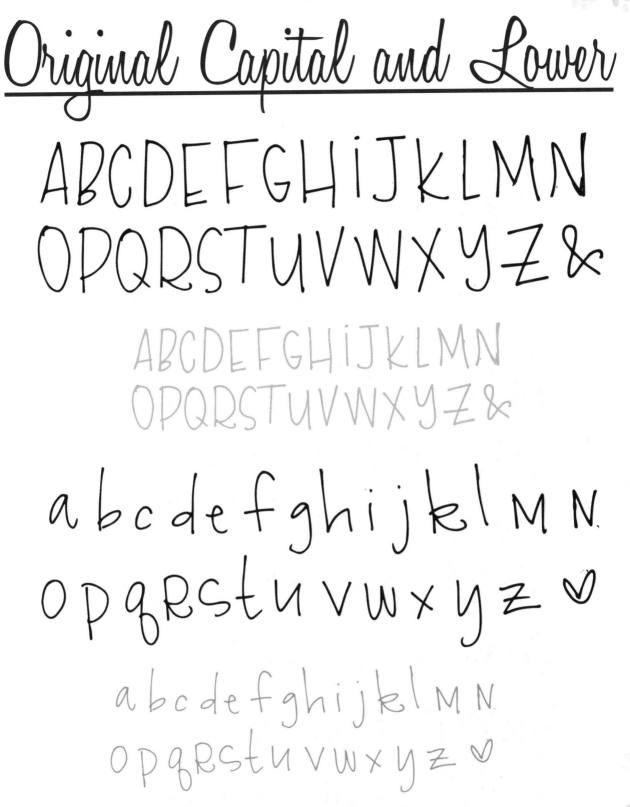

A B C D E F G H I J K L M N
O P Q R S T U V W X Y Z &

A B C D E F G H I J K L M N
O P Q R S T U V W X Y Z &

a b c d e f g h i j k l M N.
O P Q R S t u V W x y z ♡

a b c d e f g h i j k l M N
O P Q R S t u V W x y z ♡

Practice by tracing over the gray letters.

Inspiration

Use these examples as inspiration to create your own
Original Capital and Lower lettering combinations.

ABCDEF GHIJKLMN
OPQRSTUVWXYZ

APPLe BaNaNa CHeRRies
DaTe EGGplaNT FiSH GoT
HoTEL InDianS JUMPeZ
KoqLA LiME MoNKEY No
Oak Pat QUiRky RoSy
SwaMP TexAS UNiCoRN Vow
WElCoME X-ray You ZeBRq

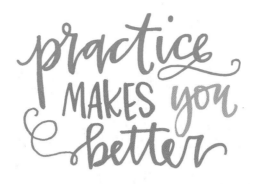

practice MAKES you better

Use this page to practice Original Capital and Lower.

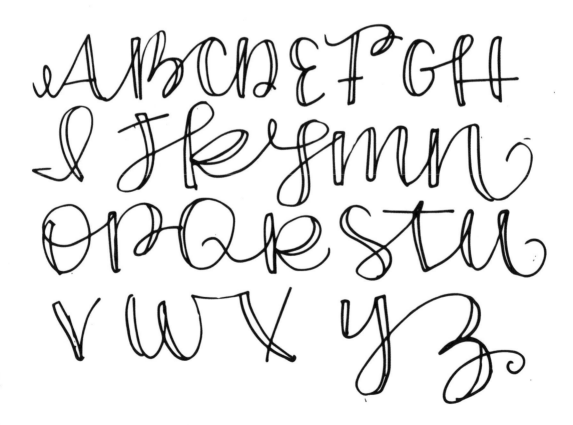

♡ Hollow letters

a b c d e f g h i j
k l m n o p q r
s t u v w x y z

A B C D E F G H
I J K L M N N
O P Q R S T U
V W X Y Z

Inspiration

Use these examples as inspiration to create your own Hollow Letters combinations.

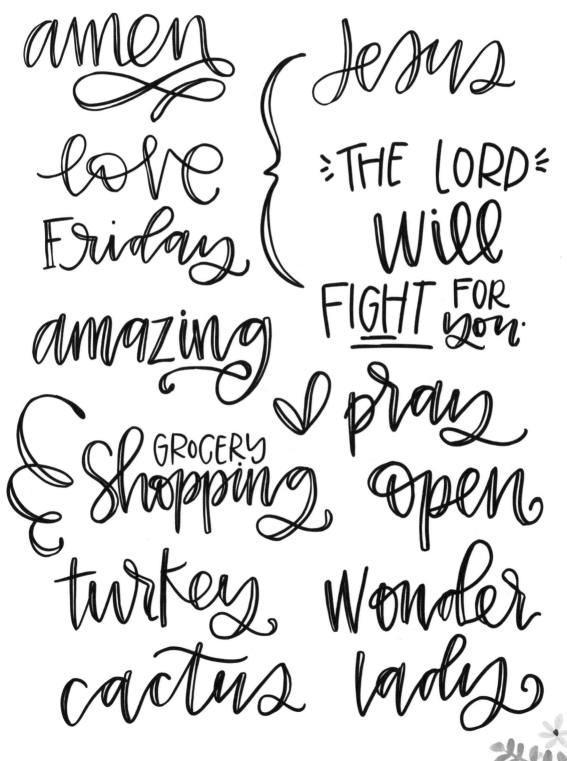

amen

love

Friday

amazing

Jesus

THE LORD WILL FIGHT FOR you.

GROCERY Shopping

pray

Open

turkey

cactus

Wonder

lady

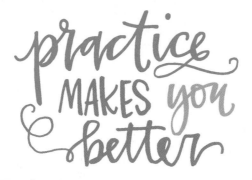

Use this page to practice Hollow Letters.

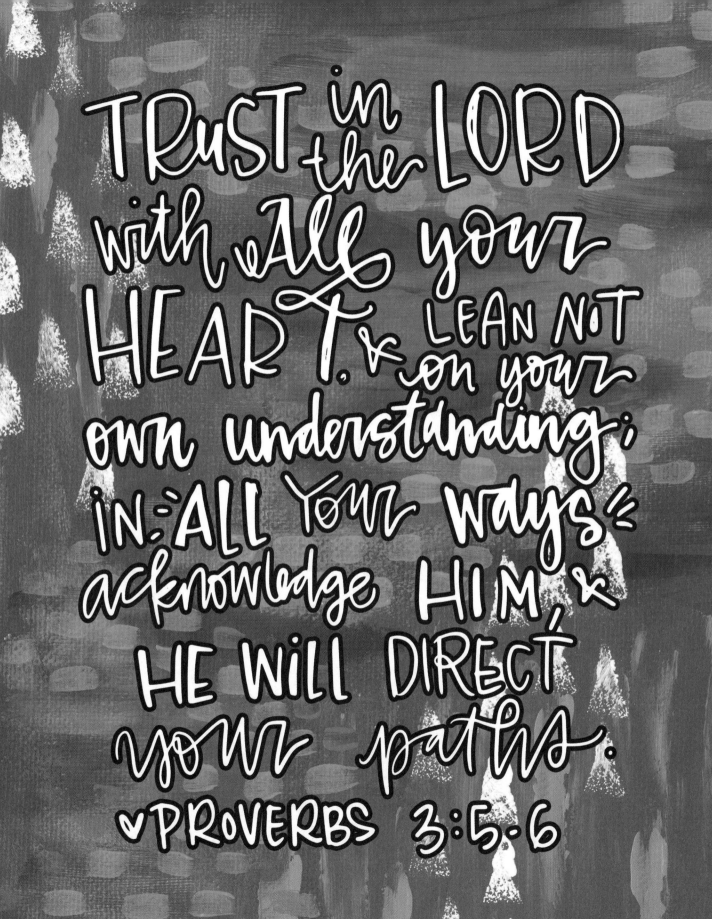

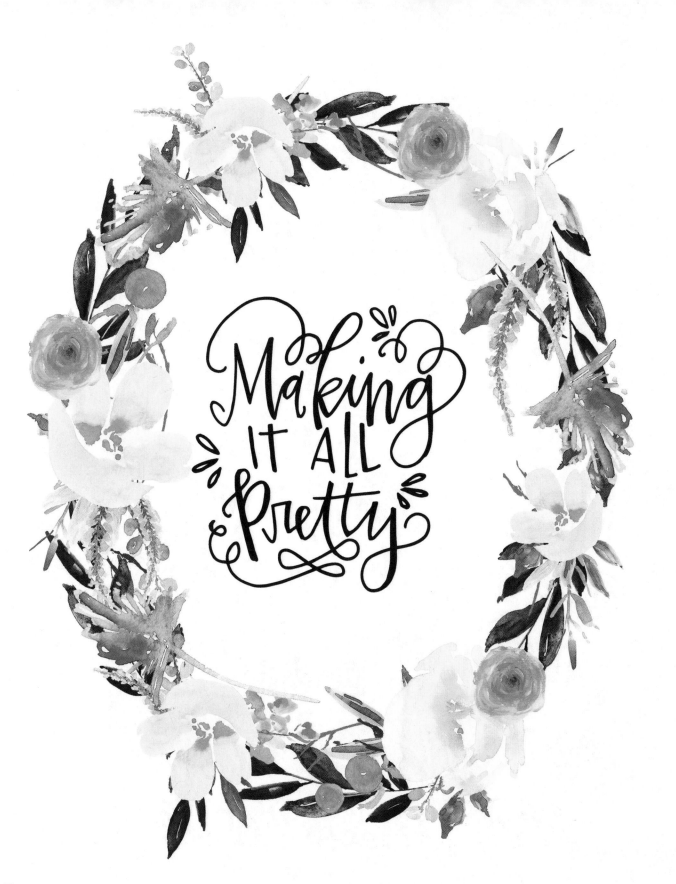

Making
It all
Pretty

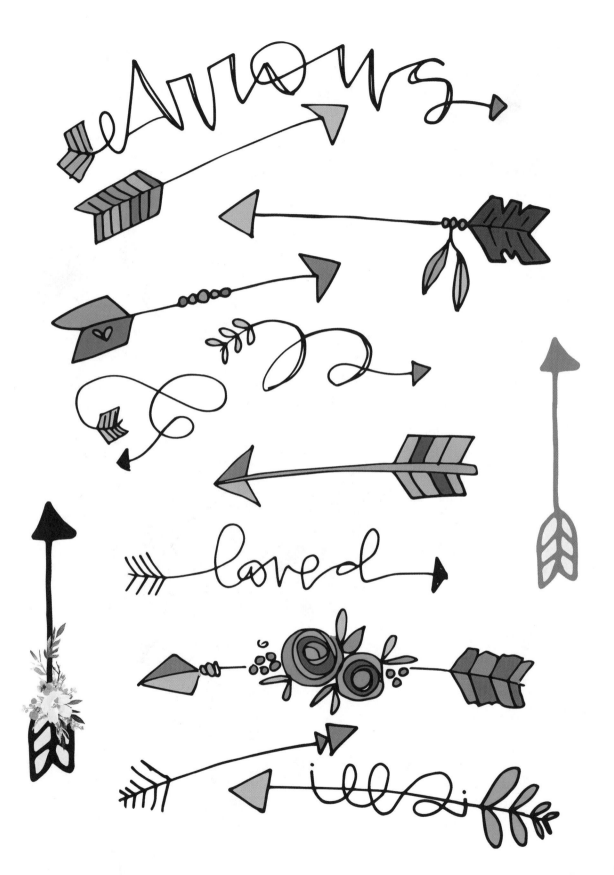

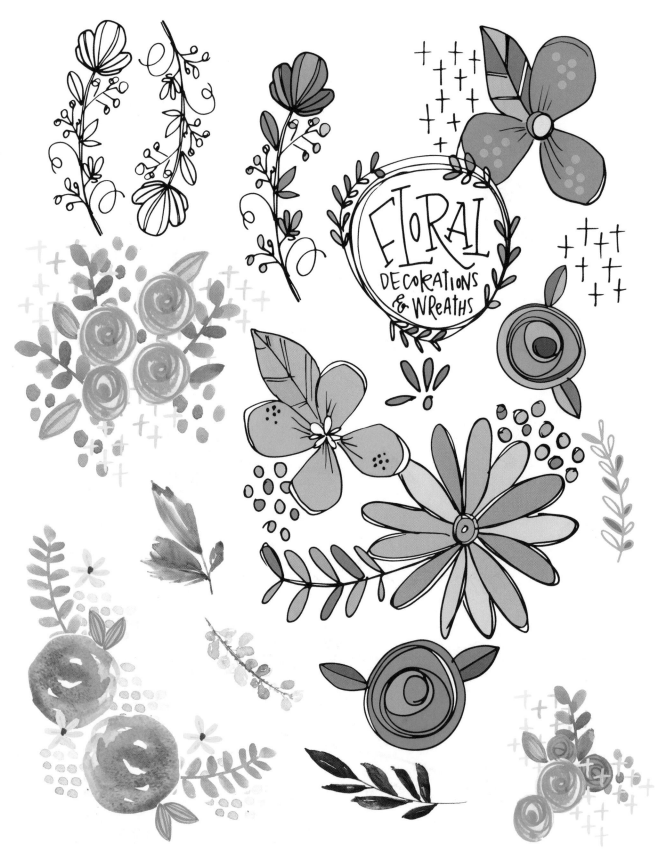

FLORAL
DECORATIONS
& WREATHS

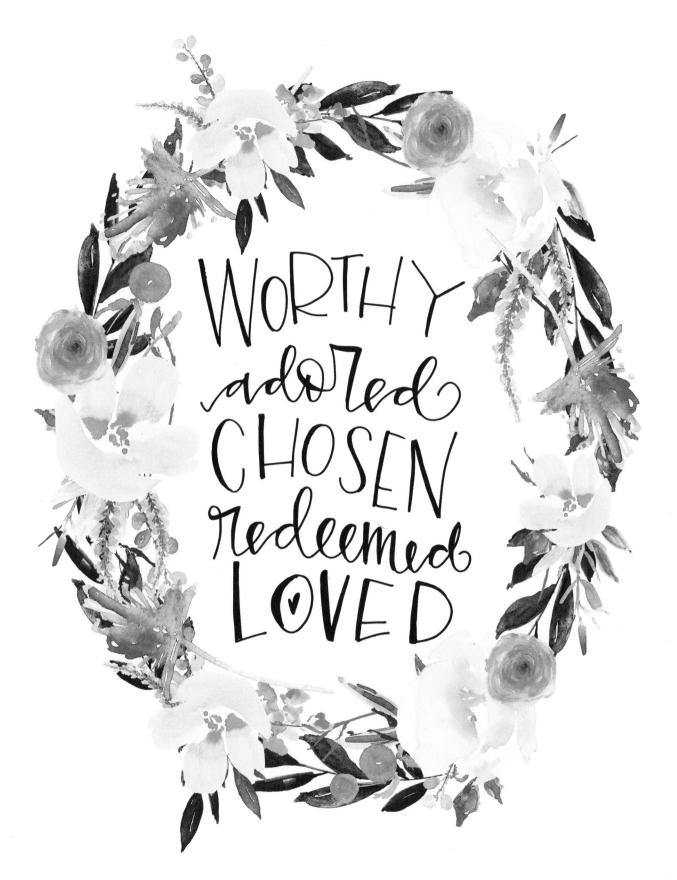

WORTHY
adored
CHOSEN
redeemed
LOVED

Flourishes

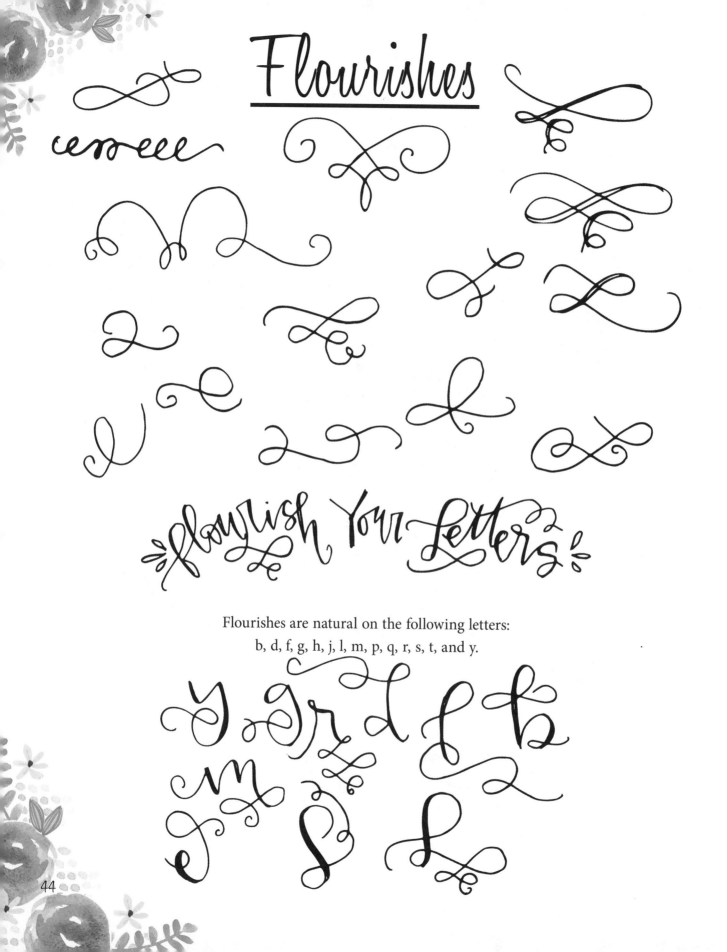

Flourishes are natural on the following letters:
b, d, f, g, h, j, l, m, p, q, r, s, t, and y.

FLOURISH

I have a notebook that I use to keep track of little flourishes that I see and ones I imagine. My pages are full of different styles that I can make my own. Use this page to keep track of your favorite little details that you see as you go about your day, that you see on Pinterest, or that you draw.

Combining Flourishes and Lettering

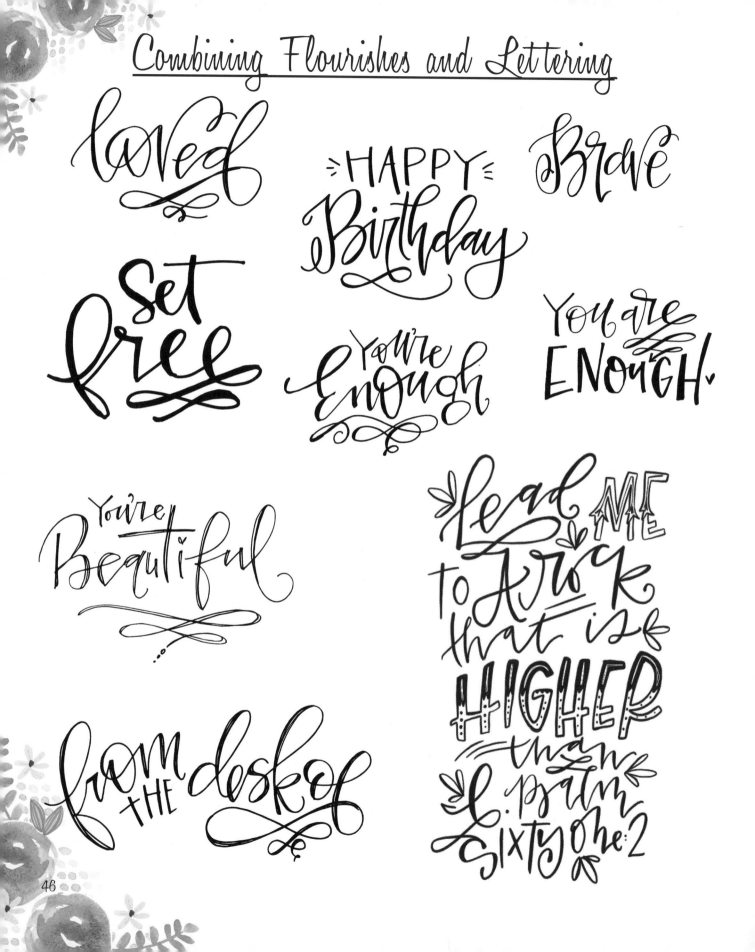

Loved

HAPPY
Birthday

Brave

Set
Free

You're
Enough

You are
ENOUGH.

You're
Beautiful

Lead me
to A rock
that is
HIGHER
than
c. psalm
sixty one:2

from the desk of

family
Valued
Blessed
Enough
joy
beautiful
Blessing
prayer
today
Please
faithful
Sweater
thanks
Lord

Use this page to practice combining flourishes with your lettering.

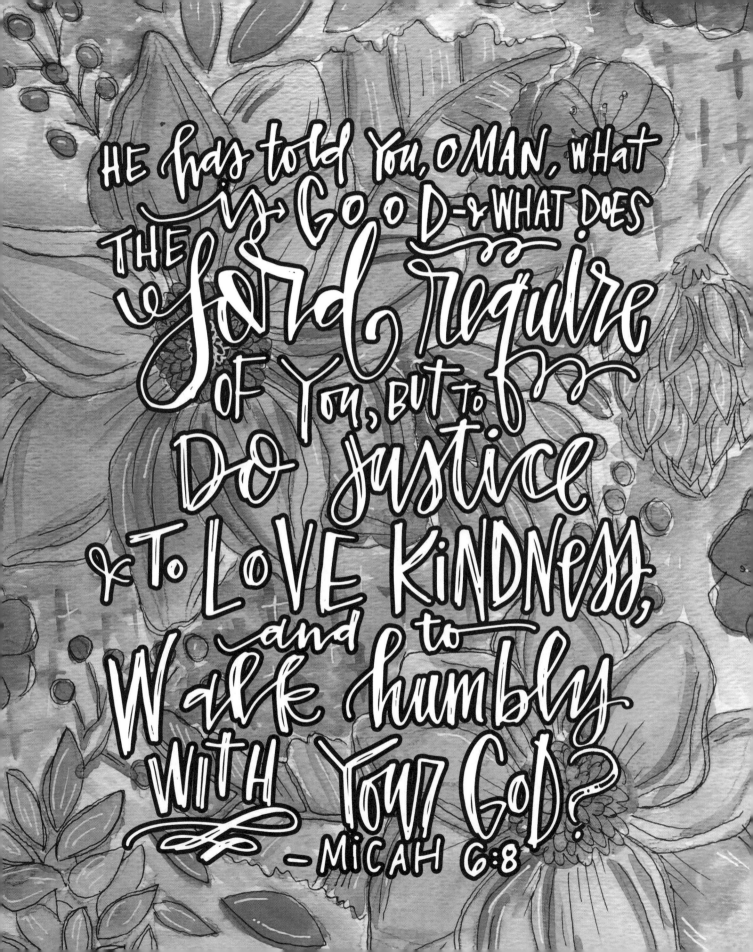

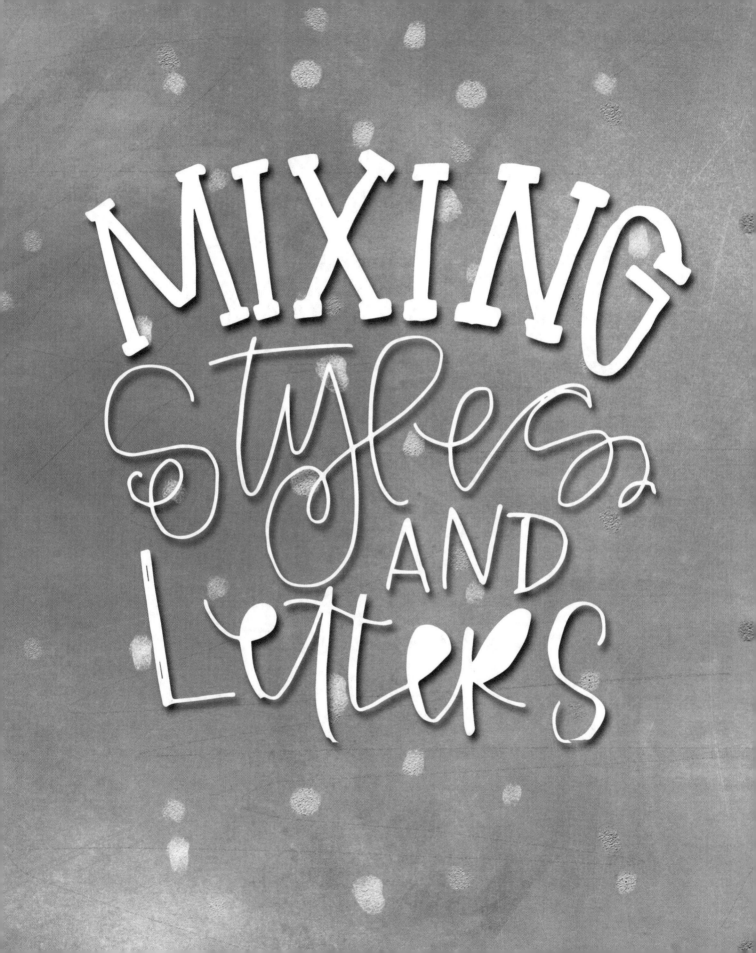

MIXING

Styles

AND

Letters

practice MAKES you better

Before you try mixing styles, write one word over and over in different styles. This is an easy and great exercise. Look at my example below as a reference for possible combinations. Pick a word of your own, and try writing it twelve times.

INSPIRED

Serif and Sans Serif

Serif and sans serif are two different types of lettering styles. Sans serif literally means "without serif." There is barely any variation of lines in sans serif lettering. In serif lettering there are smaller details on the ends of each letter. They can be all shapes and sizes.

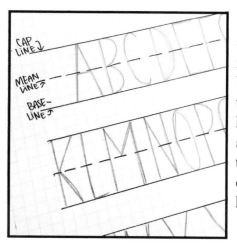

Step 1: Draw your letters out, making the bottoms touch the baseline and the tops touch the cap line. It's good to learn how to draw the letters on a straight line before breaking the rules. Remember, think of drawing letters more than learning good handwriting

Step 2: To add serifs, go back over the letter to make the downstrokes thicker. Add serifs to the tops and bottoms of the strokes.

ABCD EFGHI JKLMN OPQRS TUVWX Y and Z

SERIF

ABCDEFGHIJKLMNOPQRSTUVWXYZ

SANS SERIF

ABCDEFGHIJKLMNOPQRSTUVWXYZ

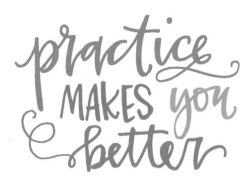

Use this page to practice drawing serifs on your letters.
Try drawing both uppercase and lowercase letters.

Thin, Bold, and Script Styles

Mixing the styles of your words and being creative with it will create a unique look that is appealing to the eye. Look at the examples below, and work on mixing your own styles in the empty space.

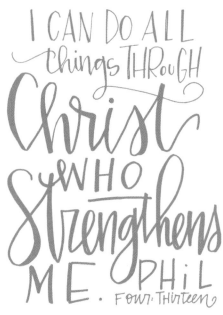

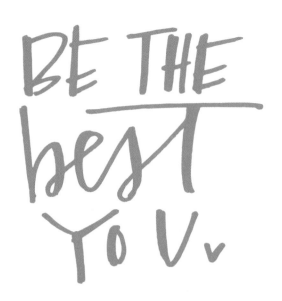

Drawing Out a Quote Using Multiple Styles

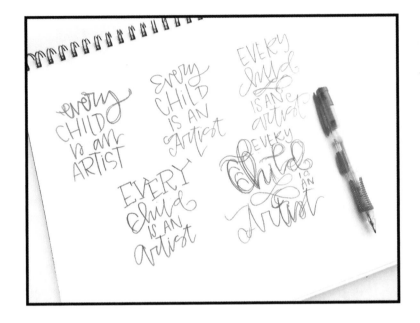

Step 1: Because variety creates unique art, pick one set of words, and draw it five different ways.

Step 2: Go back over your letters, and redraw them to fix anything that looks weird. Don't worry about what it looks like right now. You aren't inking yet; you're just letting your imagination go.

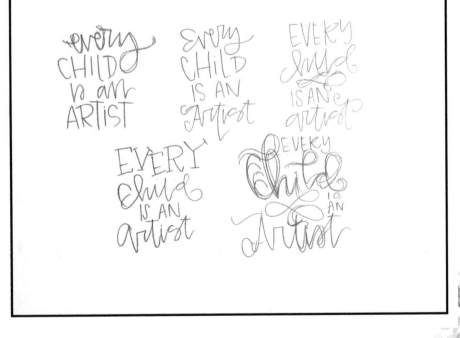

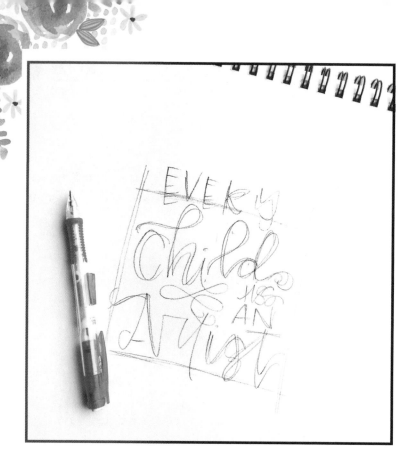

Step 3: Pick the design you like best. (My favorite is the last one I drew.) Then make sure the lines you want are pretty close to straight by drawing a line underneath them, as you see under "every" and "artist."

Step 4: Tweak the letters, and get the flourishes the way you want. Then begin inking with permanent marker.

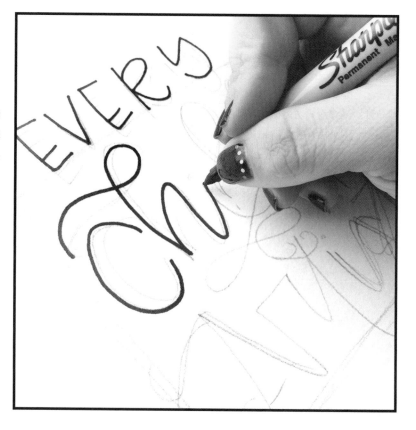

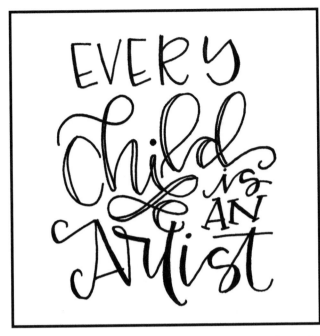

This piece mixes hollow, serif, sans serif, and script letters.

You can add something extra as well. I chose to add a frame with polka dots. You might want to add a banner or arrows. Pencil it in first, and then use ink.

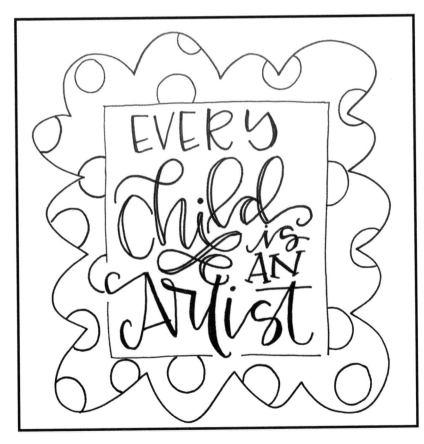

Once you have finished inking in your design, you can erase any pencil marks. You could also paint the final product with watercolors.

Use this page to practice mixing your styles. Try drawing a quote using at least four different styles, such as capital, lowercase, serif, and cursive letters.

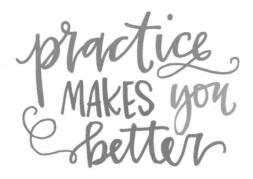

Use this page to practice mixing your styles. Try drawing a quote using at least four different styles, such as capital, lowercase, serif, and cursive letters.

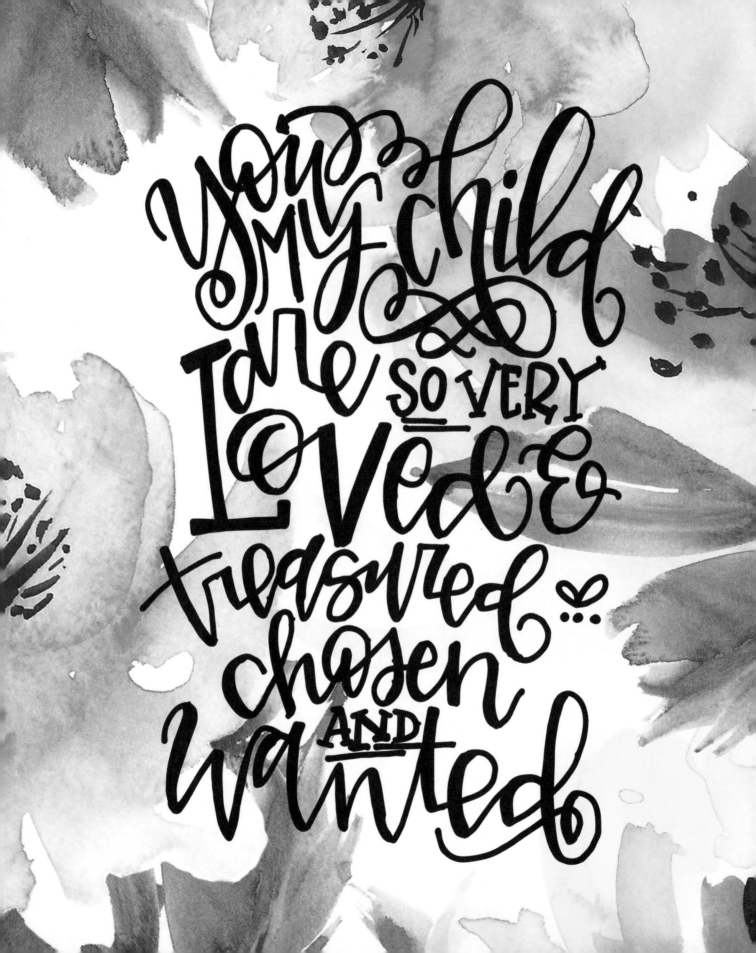

Lettering Warm-Up

Draw a short phrase three different ways. Try mixing different colors and lettering styles. Use this page and the next as inspiration, and use the following page as practice.

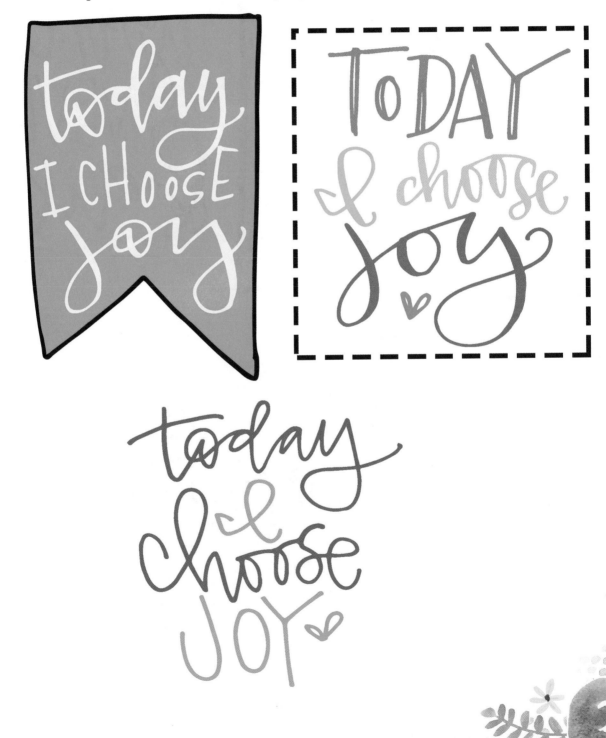

love
NEVER
fails

your love
NEVER
fails

LOVE
never
fails

Use this page to write one quote or verse three different ways.

But the LORD stood with ME and strengthened ME ♡ 2 Timothy 4:17

lettering
PROJECTS
To practice your
skills

Hand-Lettered Tags

Materials:

- Any size tag punch. Punches can be found in craft stores around paper products and usually come in a variety of sizes and shapes.

- A variety of colored paper

- A Sharpie and a pencil

- A hole punch

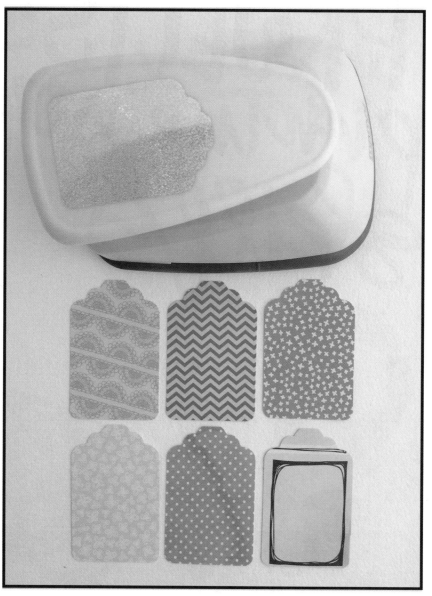

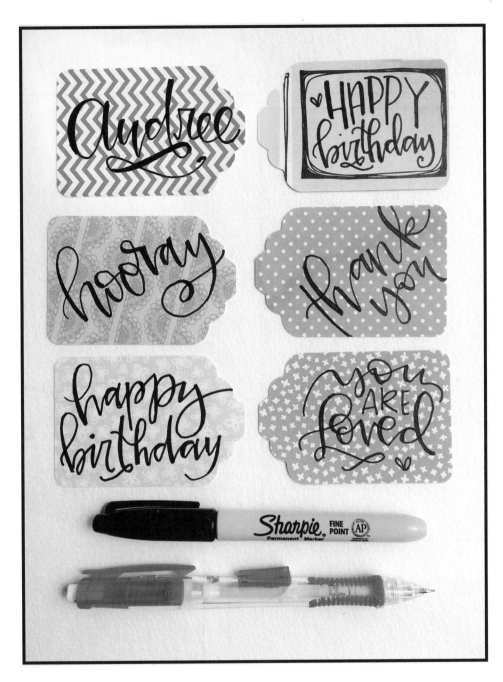

Step 1: Make a list of all the tags you want.

Step 2: Use the tag punch to create your tags.

Step 3: Trace all the words you want on your tags.

Step 4: Put the design on with a permanent marker.

Step 5: Pierce the tags with a hole punch, and use some ribbon to attach to a gift.

Watercolor Hand-Lettered Tags

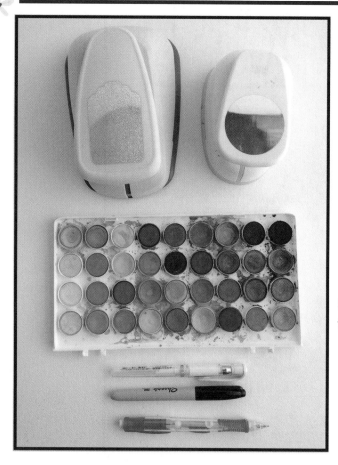

Materials:

- Tag punches (any size or shape)
- Watercolors
- A paintbrush
- Pens
- A pencil
- Washi tape
- A hole punch

Step 1: Punch out as many tags as you would like.

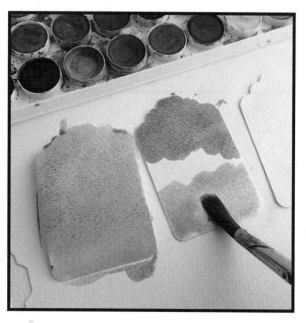

Step 2: Paint each tag with watercolor by splotching it on with your brush. There is no real trick to this. Just place color anywhere.

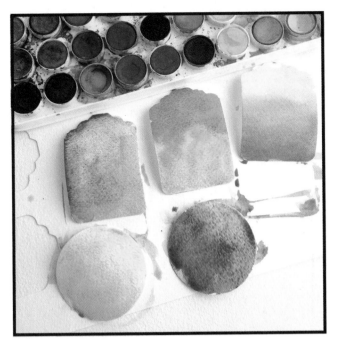

Step 3: Allow the watercolors on the tags to dry completely. Writing on wet paper will ruin your marker tips—that's every letterer's nightmare!

Step 4: Once the tags are dry, add details to the tags. On these tags I added detail with gold liquid acrylic paint. Next, add the letters with a Sharpie. Attach your tags with ribbon or washi tape once finished.

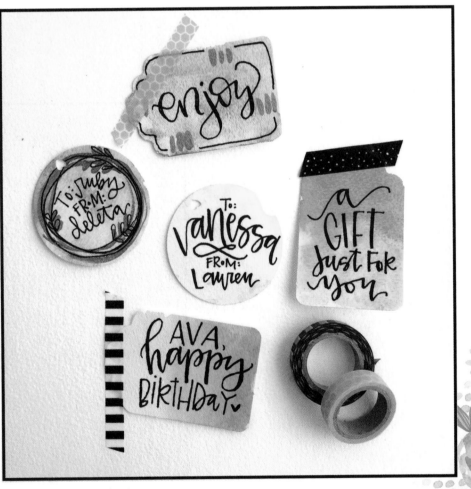

Wrapping Paper

Materials:

- Brown kraft paper
- Acrylic paints
- A small paintbrush
- Scissors
- Curling ribbon (optional)

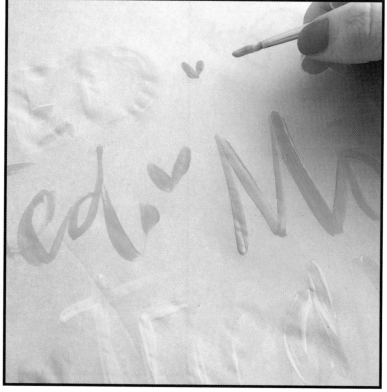

Step 1: Pick three paint colors that coordinate well together. For this project I picked baby blue, mint, and light pink.

Step 2: Begin painting words on the kraft paper. I started in the middle and worked diagonally, but you can begin writing anywhere. It will look cool no matter what.

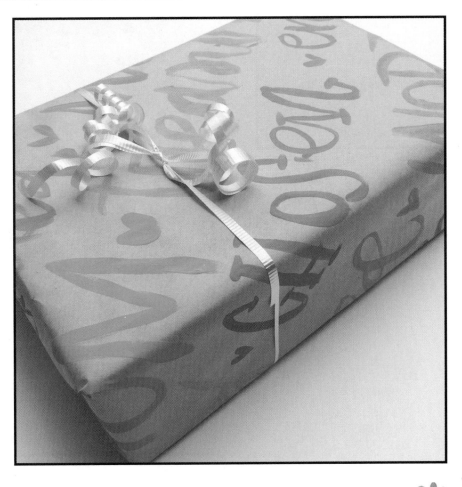

Step 3: Once you have finished up the lettering on the paper, let the paint totally dry. Begin wrapping your gift as usual.

The finished project looks great with the addition of curling ribbon.

Materials:

- Computer paper
- A pencil
- A Sharpie
- Acrylic paint
- A small paintbrush
- Canvas

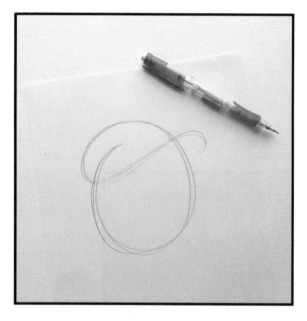

Step 1: Take your sheet of computer paper, and draw out the letter of your choice using a pencil. You may want to draw several different styles of the letter and then pick the one you would like to end up on your canvas.

Step 2: Go over your letter with a Sharpie. Trace the lines over and over to create a letter that looks "doodled." You'll want to create enough lines that you will be able to paint and add details.

Step 3: Pick out up to five paint colors that go together. Paint those colors on the page to make sure they look pleasing to the eye. Red, pink, orange, and yellow look good together. Yellow, green, blue, and purple do as well.

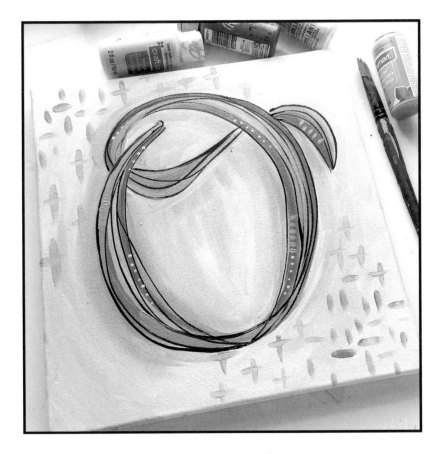

Step 4: Draw your letter onto the canvas with a pencil. Go over your lines with black paint and a small brush. Color in each section with one of the colors. Then go over the colors with different colors to make details. In my *o* I used a dark blue to color in one section and then used a lighter blue to make a stripe and a yellow to make dots. After the letters look the way you like, color the background of the canvas gray. This will really make the painted letter pop.

Use this page to practice drawing a letter before drawing out the final
product on watercolor paper, painting paper, or canvas.

Wooden Sign

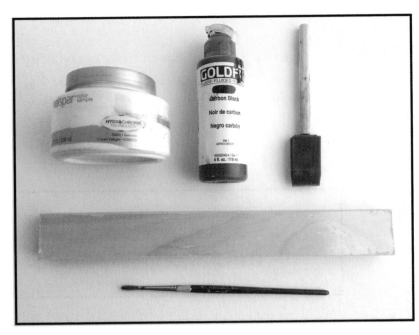

Materials:

- Acrylic paint
- A sponge brush
- A wooden strip
 (This is a 2-inch-by-12-inch piece.)
- A small paintbrush for lettering
- A pencil
- An eraser

Step 1: Using a sponge brush, paint the edges of the wood strip. I chose gray paint for this project.

Step 2: Paint the base coat on the surface of the wood. I chose to use a paint sample of Valspar wall paint in satin cream.

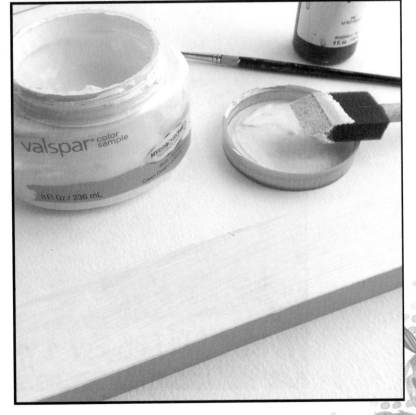

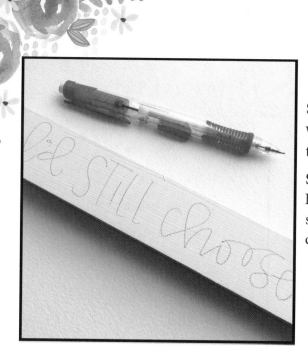

Step 3: Once the paint is dry, pencil in the design you would like. This is a great opportunity to use multiple lettering styles.

Step 4: Go over the pencil designs with black acrylic paint. I go over the letters once and then go over the downstrokes again for a fake calligraphy look. Once the paint is dry, erase all the pencil lines.

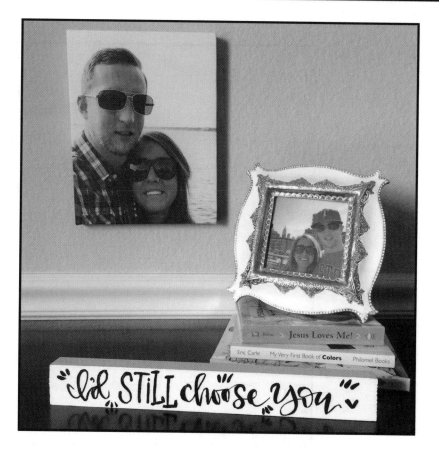

Gouache-Painted Quote

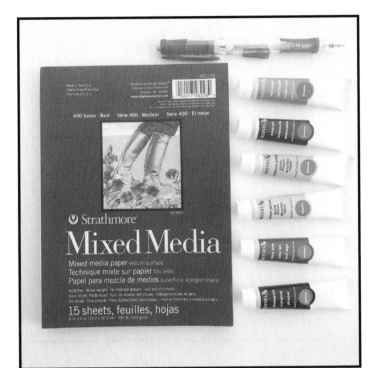

Materials:

- Mixed-media paper
- Gouache
- A pencil
- A paintbrush
- Water
- A palette
- An eraser
- A gel pen

Step 1: Pencil in the words or quote you would like to paint.

Step 2: Place dots of gouache onto your paint palette. Mix each color with a tiny bit of water. Gouache is similar to watercolor, so just add water as you need.

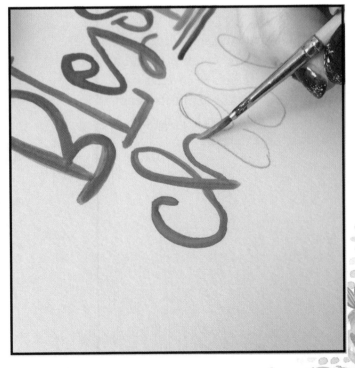

Step 3: Go over all of the pencil lines with the gouache, mixing colors into each other. I started with green, mixed in some blue, and then went back to green.

Step 4: Let dry, and then erase all of the pencil marks. They should erase easily, and the paint shouldn't smear. The less pigment you use going over the pencil, the less likely it is to smear when you use the eraser.

Step 5: Go over any spots where the pencil marks are coming through the paint. Once you've covered your pencil spots, let the paint dry completely. Add details with your gel pen. (I used a white Signo pen.)

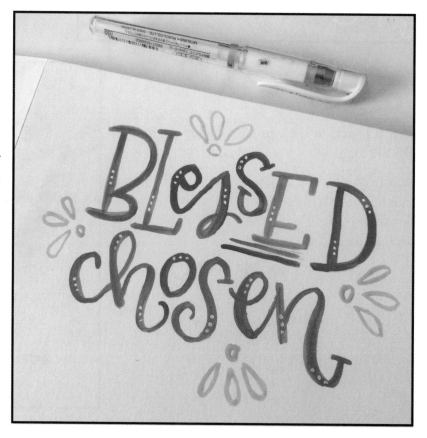

Painted Canvas

Materials:

- Canvas
- Tubes of acrylic paint
- White acrylic paint (I am using Golden brand fluid acrylic in titanium white.)
- Chalk
- A paint palette
- A paintbrush

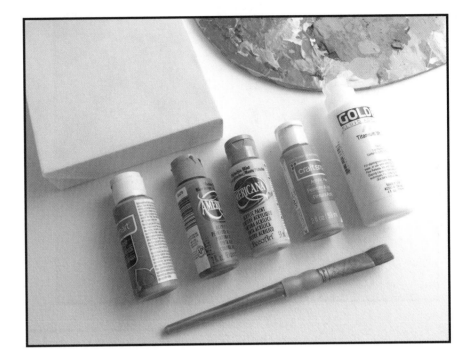

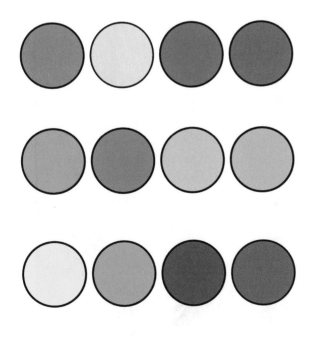

Step 1: Pick four colors that go well together that you would like to use to paint your canvas. I have included three color combinations here that look great together painted on canvas. I painted my canvas using the top color combination.

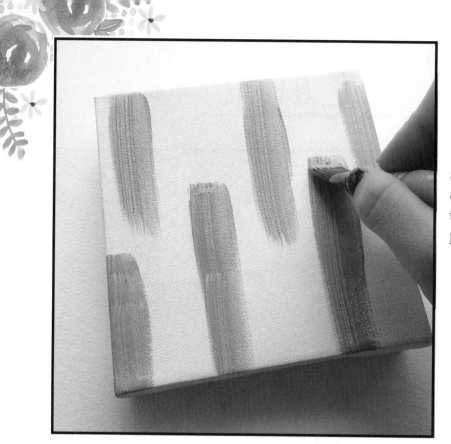

Step 2: Paint the canvas using one of the lighter colors. Paint some vertical streaks. The whole canvas will be painted using streaks of paint.

Step 3: Add vertical lines of the next light color. Don't worry about the first color being completely dry. It's OK if the colors mix together.

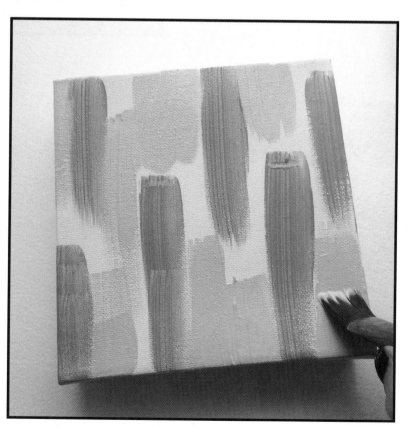

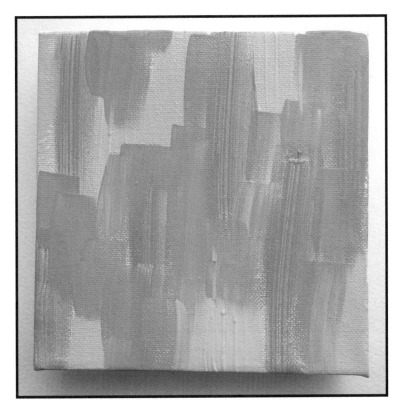

Step 4: Cover the rest of the white space with the third color using downstrokes.

Step 5: Add the last color using small strokes. Then go over the areas that are still missing color with one of the other colors. I went over mine with the mint color that I used second.

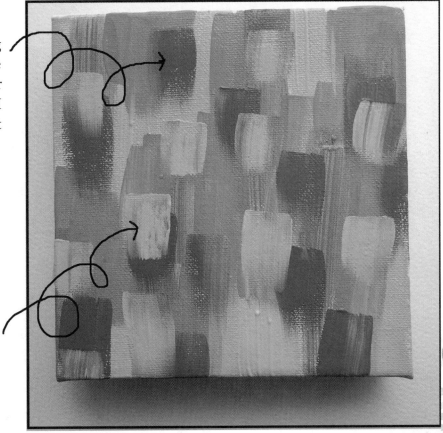

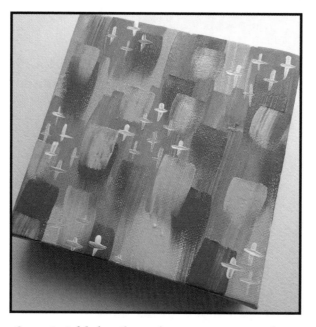

Step 6: Add details to the canvas using white paint. I used little plus signs, but you could also use polka dots or squares.

Step 7: Once the canvas is dry, letter your words onto it. I like to lay mine out with white chalk first to guide me. Trace over your chalk words with black paint. Once you are finished, seal the canvas with spray varnish to protect the paint.

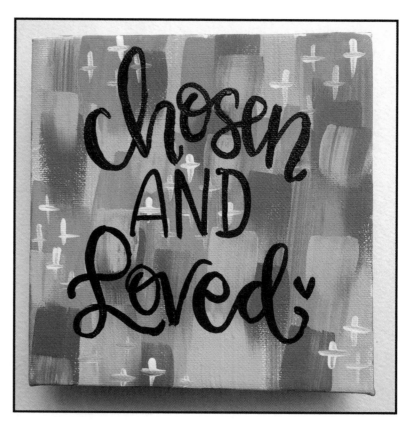

Hand-Lettered Cards

Materials:

- Precut blank cards (any size or color)
- A permanent marker
- A white gel pen
- An eraser

Step 1: Draw out your words on three different cards at once. Practice your flourishes on at least one. (I did this on my pink card.) Practice mixing different styles on one. (I did this on my orange card.) On the last card feel free to explore and try something new.

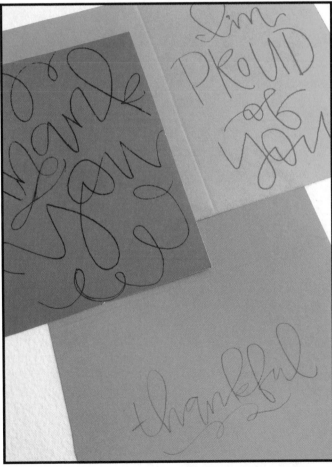

Step 2: Outline your pencil marks with a permanent marker.

I'm PROUD of YOU

thank you

Step 3: Add details. I added white polka dots. Fun details add an extra pop that will make your card stand out. Enjoy the final product.

Hand-Lettered Envelopes

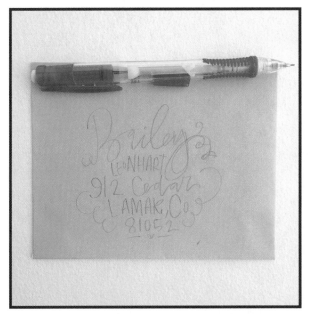

Materials:

- Envelopes
- A pencil
- Markers

Step 1: Draw out each design with a pencil.

Step 2: With a permanent marker trace over your final design. On black envelopes I love to use a gold or bronze Sharpie.

Step 3: Add details such as flourishes, arrows, lines, and polka dots to give your envelope the extra pop it needs to stand out.

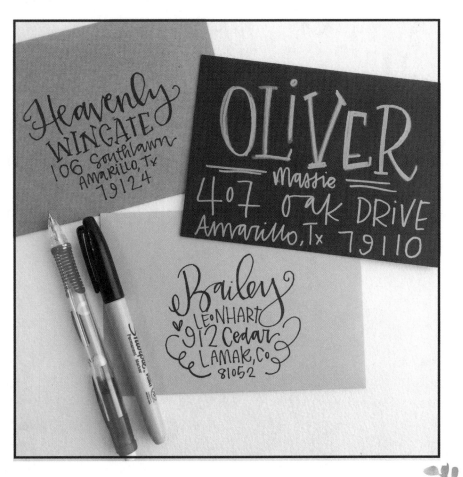

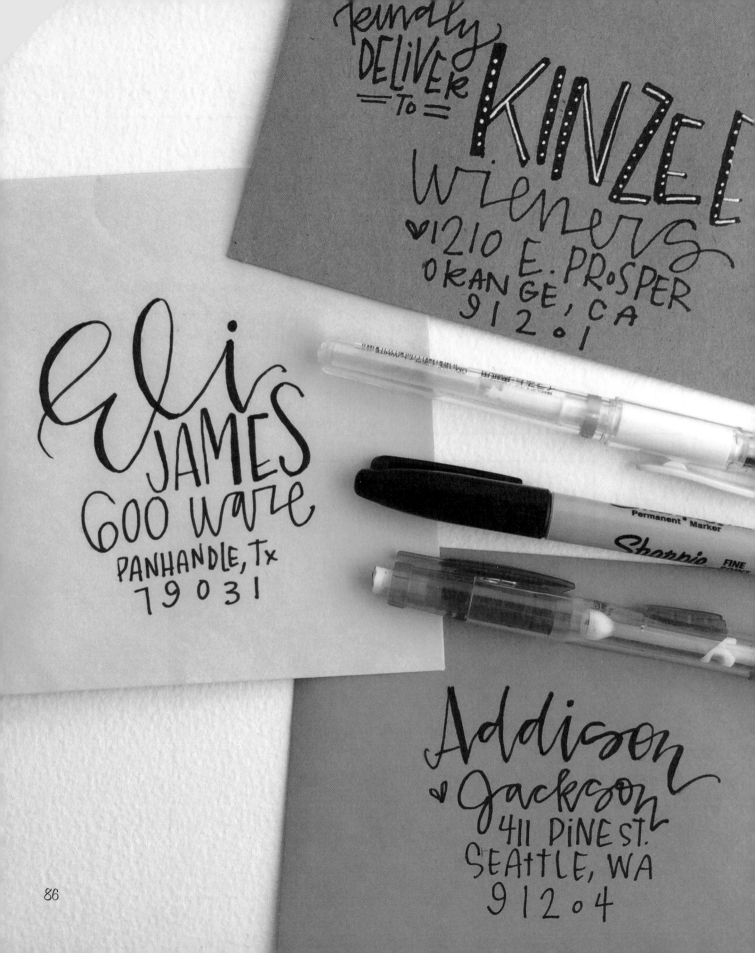

kindly
DELIVER
= TO =
KINZEL
wieners
♥ 1210 E. PROSPER
ORANGE, CA
9 1 2 0 1

eli
JAMES
600 ware
PANHANDLE, Tx
7 9 0 3 1

Permanent° Marker
Sharpie FINE

Addison
♥ Jackson
411 PINE ST.
SEATTLE, WA
9 1 2 0 4

86

Scrapbook Page

Materials:

- Scrapbook paper
- Washi tape
- An acrylic block
- Acrylic stamps
- A marker
- A pencil
- Pictures
- Archival Ink

Step 1: Lay out your photos where you want them, and stick them down with washi tape.

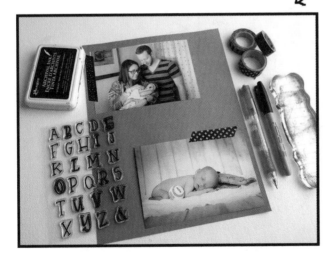

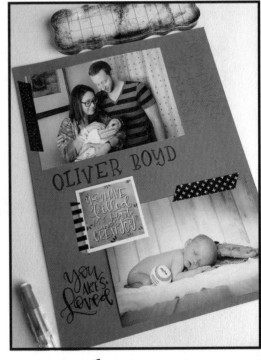

Step 2: Letter in the words you want on your page with pencil. Once you have it layed out, ink in the words with a marker.

Step 3: In the empty spaces use acrylic stamps. This is also the time to add any embellishments to your page.

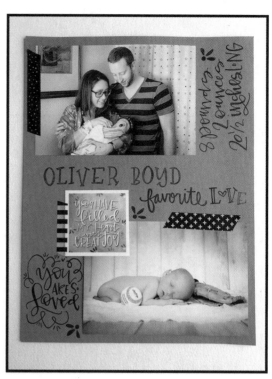

Step 4: Add small stickers to finish off the page.

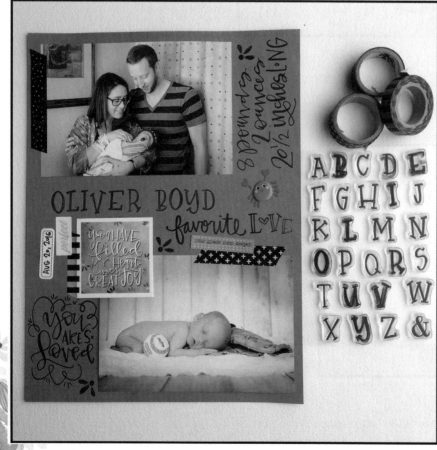

Chalkboards

Chalkboards are a fun way to practice lettering. You can easily erase your mistakes and try out what works and what doesn't.

If you have a brand-new chalkboard, you will need to "season" it so that it is easy to write on. You do this by rubbing your chalk all over the board and then erasing. I like to do this a few times before I get started. In this section you will learn how to create a floral wreath on a chalkboard that gives you plenty of room to letter inside.

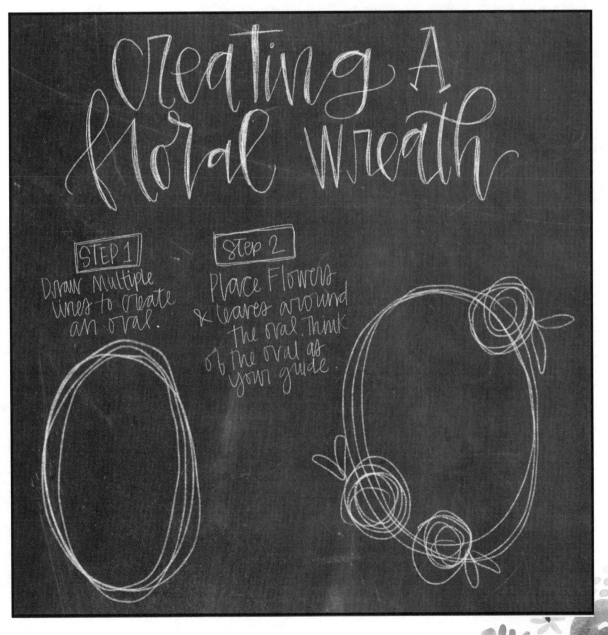

Creating A Floral Wreath

STEP 1
Draw Multiple lines to create an oval.

STEP 2
Place Flowers & leaves around the oval. Think of the oval as your guide.

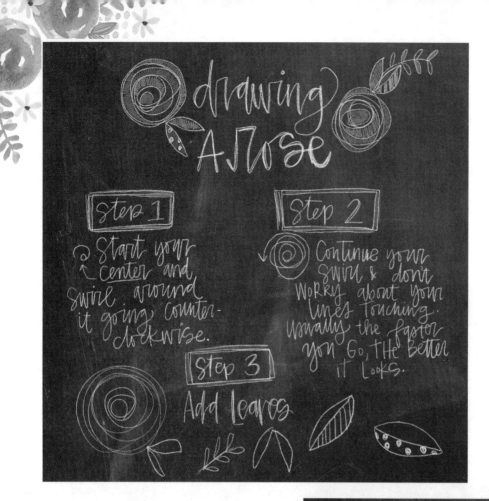

drawing
A rose

Step 1
↳ Start your center and swirl around it going counter-clockwise.

Step 2
Continue your swirl & don't worry about your lines touching. Usually the faster you go, the better it looks.

Step 3
Add Leaves

Use the blank space to practice different styles of leaves and flowers.

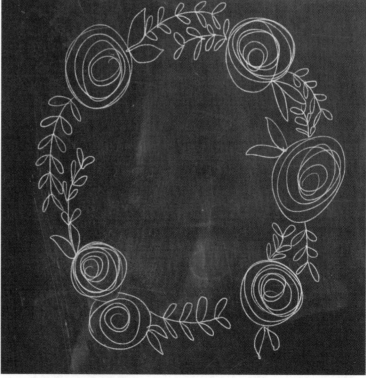

Once you have filled in the flowers and leaves, you can erase the extra lines. I like doing this with a small paintbrush. After my extra lines are gone, I go over the chalk that is left one more time to make it stand out and add lettering.

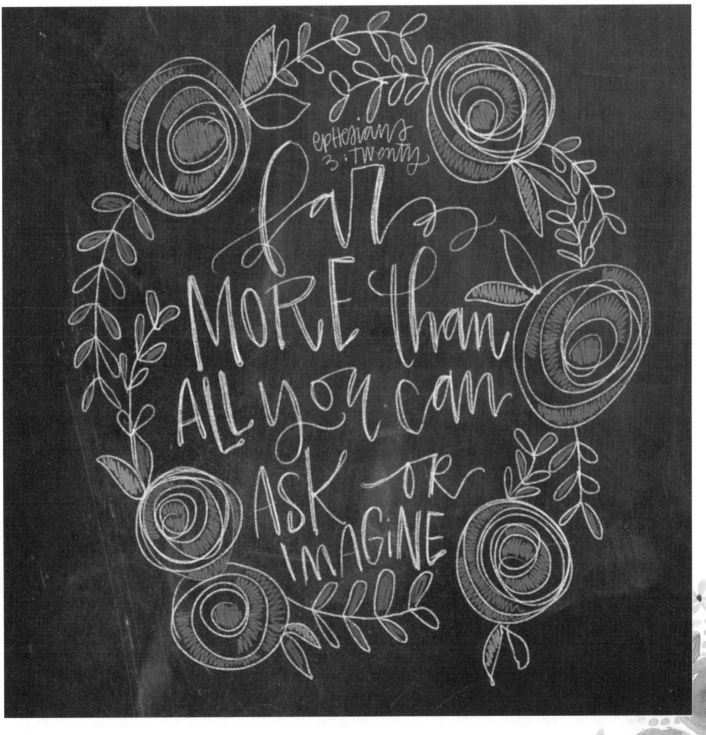

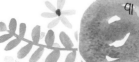

BIBLE journaling

Glue stick

Watercolor paints

Markers and pens

Washi tape

Journaling Bible

Acrylic paint

BIBLE journaling

Bible journaling is one of those things that you come across and never give up. I found out in the summer of 2014 that journaling Bibles existed and have been journaling in my Bible ever since. A journaling Bible is just like a regular Bible, except it has a large margin on both sides so you can draw, doodle, journal, or paint. The pages are thin, the same as a regular Bible, but surprisingly they still hold up to the things I stick on them. There is some bleeding that happens, but that is just part of the beauty. Making a beautiful page out of the bleed is part of the process.

I love using acrylic paints, watercolor paints, and things I find in my journaling Bible. If you think of it like a scrapbook, it is so much fun. I am currently on my fourth journaling Bible, and it's so fun to look back and see how my style has changed and how it has been influenced by those around me. Don't be so concerned with messing up. You can't mess up in art. Grab some pens you have lying around and maybe some crayons from your kid's room, and get started. It's all about your heart and what kind of legacy you want to leave for those who see it when you're gone.

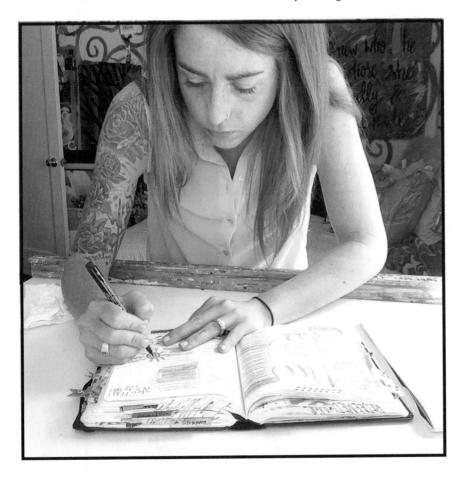

My favorite supplies:

- A mechanical pencil
- A Pentel Sign Pen
- A Faber-Castell brush pen
- Sharpie pens
- Crayola Twistables
- Tombow markers
- Artist's Loft watercolors
- Inexpensive tubes of acrylic paint
- A water-brush pen
- Washi tape
- Alphabet stickers
- Scrap pieces of paper
- A glue stick
- A tab punch

There are so many different ways to approach Bible journaling, but in this tutorial I will show you one of the simplest and one of my favorite ways.

Materials:

- A journaling Bible

- A pencil

- A black marker (I am using the Pentel Sign Pen.)

- Artist's Loft watercolors

- A paintbrush or water-brush pen

- Washi tape

- Alphabet stickers

- A glue stick

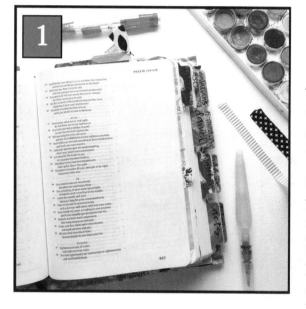

Step 1: Grab your Bible and the supplies you want to use. You don't need to prep your pages or use gesso to make them thicker. It's a Bible, so it will have thinner pages. One of the best parts is hearing the pages crinkle once they have dried completely.

Step 2: Draw out your design, and make any changes you want to see. Consider adding designs such as flourishes or any other decorations.

Step 3: Ink in your design with a waterproof marker. Faber-Castell and Pigma Micron are great brands; you can also use a Sharpie pen. I am using the Pentel Sign Pen here.

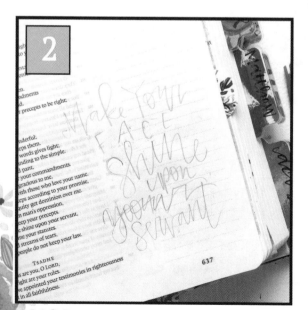

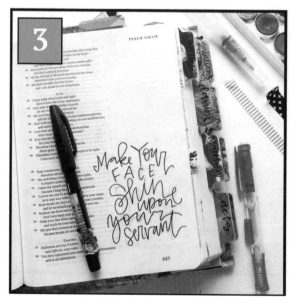

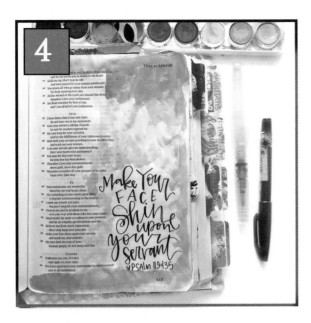

Step 4: Add splotches of paint that will look great together all around your words. Cover the page but not the words of the Bible or lettering. On this page I used the Artist's Loft watercolors and my water brush pen to spread the paint. Warm colors look great with one another, and so do cool colors.

Step 5: Add all of the top layers, such as stickers or washi tape. I also generally make a tab with my tab punch and attach it with a glue stick. You can also use acrylic stamps and an Archival Ink stamp pad. The Archival Ink will be waterproof, so you can add paint on top of it without smudging your page. The final step is to add the date somewhere on the page so you can look back and remember when you did it!

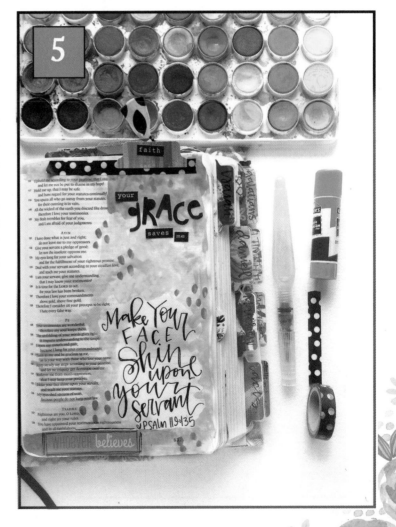

These pages were all created this past year. I used both acrylic and watercolors on the pages. I made these more as scrapbook pages. The last photo is the first page I made after our son was born. I wanted to remember his height and weight in my Bible and also include a prayer for him.

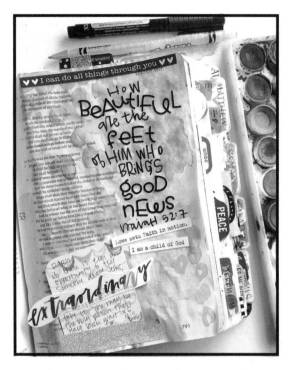

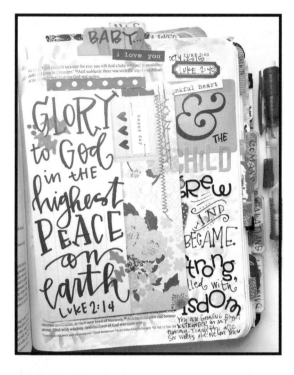

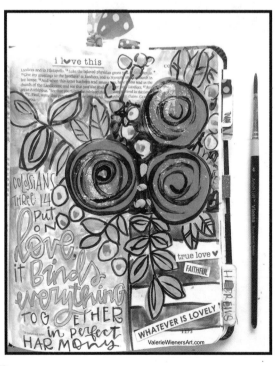

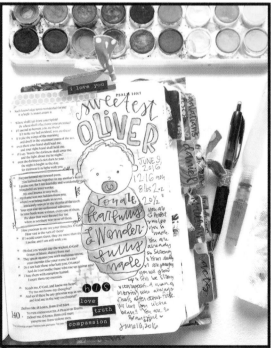

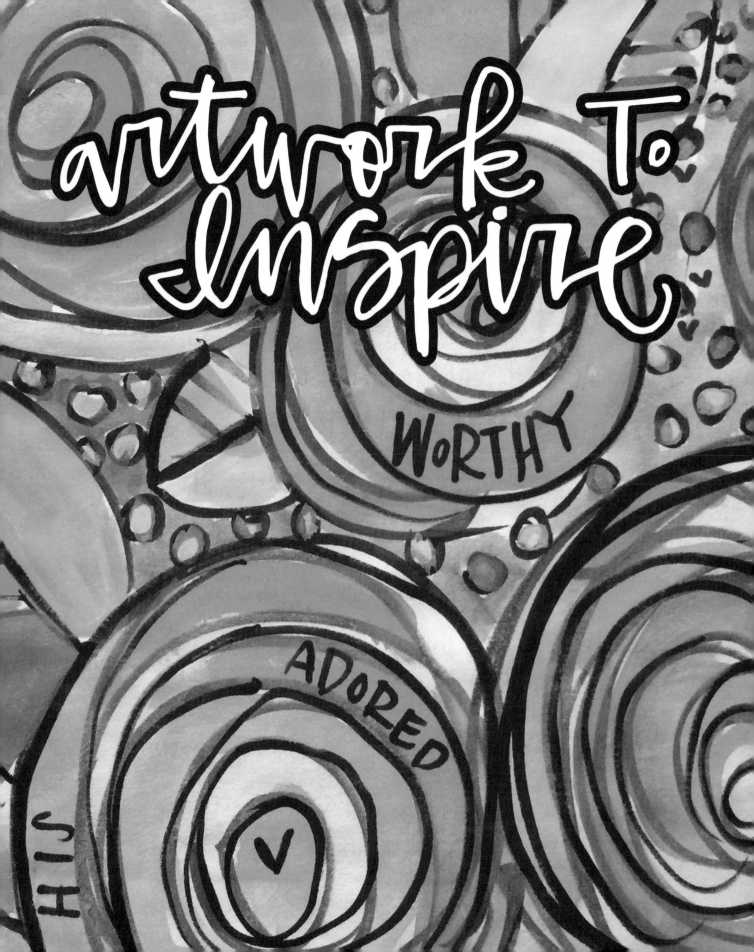

Inspiration

Use these words as inspiration when creating your own art.

Beautiful beautiful BEAUTIFUL
CHOSEN chosen WORTHY Worthy
faithful FAithful FAITHFUL faithFUL
ADORed adored ADORED adored
redeemed REDEEMED Redeemed
transformed TRANSFORMED HIS
GReater greater greater GREATER
greater is HE WHO is IN Me... treasured TREASURED
Love Love LOVE ♥♥♥ Love ♡
thankful THANKFUL Thankful !!!
Amen! amen AMEN Amen!!
CHANGEd changed CHANGEd changed
Enough Pure valued enough

Color and Letter Tags

Cut out and color or letter these tags to use on gifts.

BE BRAVE

happy BIRTHDAY

Chosen

* Several pages in this section require cutting. If you would rather not cut these pages, make a personal copy for yourself.

99

Bookmarks

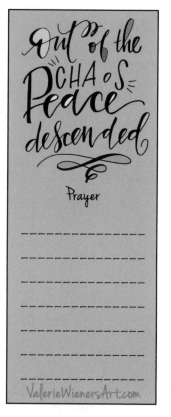

Out of the
CHA o s
Peace
descended

Prayer

ValerieWienersArt.com

On Christ the
SOLID
rock
I stand
ALL other
ground is
SINKING
sand

valerie

ValerieWienersArt.com

Color and cut out the
bookmarks on this page
and the next.

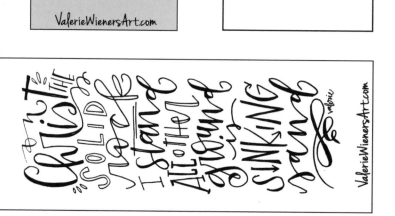

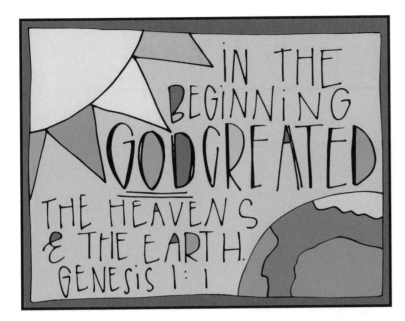

In the beginning God created the heavens & the earth. Genesis 1:1

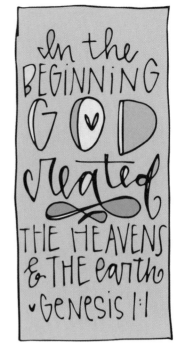

In the beginning God created the heavens & the earth. Genesis 1:1

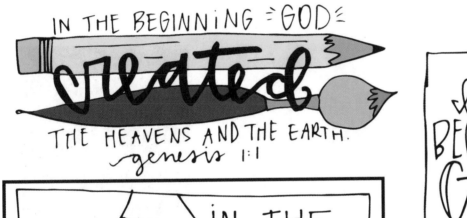

In the beginning God created the heavens and the earth. genesis 1:1

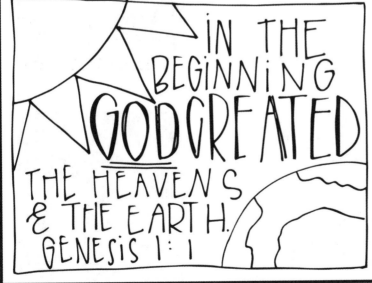

In the beginning God created the heavens & the earth. Genesis 1:1

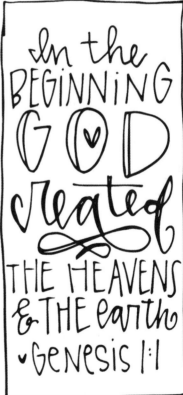

In the beginning God created the heavens & the earth. Genesis 1:1

Inspirational Cards

Cut out these inspirational cards, and place them where you need to see them most.

rise up and PRAY
LUKE 22:46

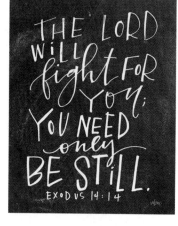

THE LORD will fight FOR YOU; YOU NEED oney BE STILL.
EXODUS 14:14

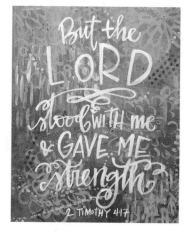

But the LORD stood with me & GAVE ME Strength
2 TIMOTHY 4:17

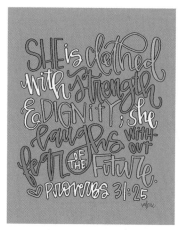

SHE is clothed with strength & DIGNITY; she laughs without fear of the future.
PROVERBS 31:25

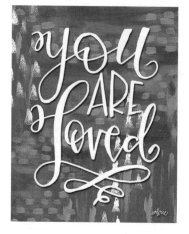

you ARE Loved

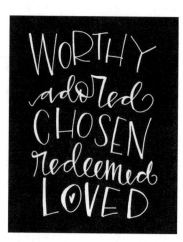

WORTHY adored CHOSEN redeemed LOVED

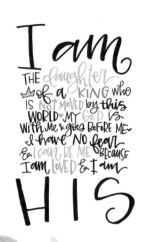

I am THE daughter of a KING who is NOT MOVED by this WORLD. MY GOD is with me & goes BEFORE ME. I have NO fear & I can BE ME BECAUSE I am LOVED & I am HIS

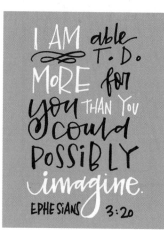

I AM able T. DO. MORE for you THAN YOU could POSSIBLY imagine.
EPHESIANS 3:20

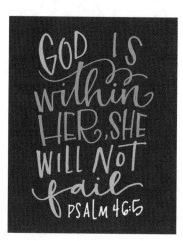

GOD IS within HER, SHE WILL NOT fail
PSALM 46:5

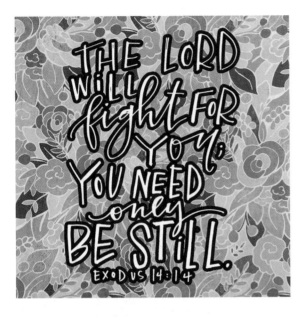

THE LORD WILL fight FOR YOU, YOU NEED only BE STILL.
EXODUS 14:14

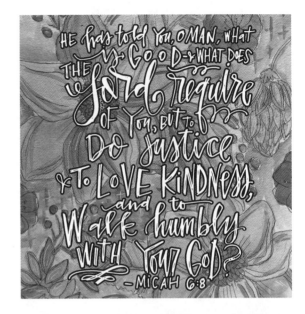

HE has told You, O MAN, WHat THE GOOD & WHAT DOES the Lord require OF You, BUT to DO Justice & TO LOVE KINDNESS, and to Walk humbly WITH YOUr GOD? —MICAH 6:8

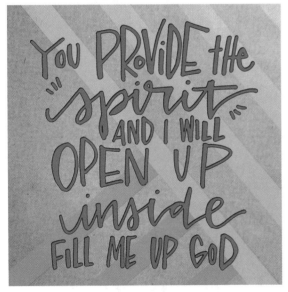

You PROVIDE the spirit AND I WILL OPEN UP inside FILL ME UP GOD

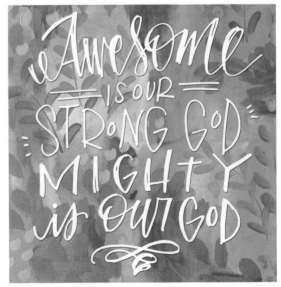

Awesome IS OUR STRONG GOD MIGHTY is OUR GOD

Use these templates to create your own inspirational cards.
Color, letter, and cut them out.

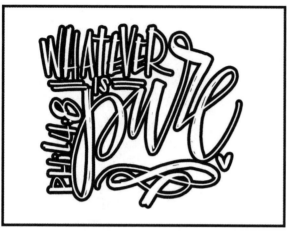

Mirror Cards

If you walk into my house, you will see scripture everywhere. If you walk into my room or look into any mirror, you'll find "mirror cards." These are cards with verses to help you with scripture memorization and adding positive thoughts to your brain. I found myself thinking the worst thoughts as I stared into mirrors. So I started fighting my terrible thoughts by taping up Bible verse mirror cards. After a few days of reading and rereading them, I noticed that sticking the Word in my head was changing my attitude. These are perfect for teenagers and adults alike.

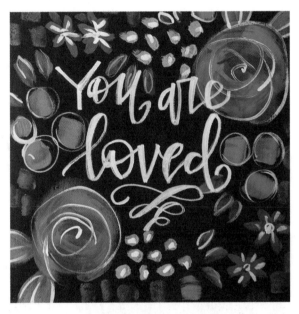

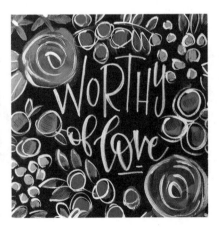

Enlarge, color, and cut these out. These would be fun to use on presents, put in lunch boxes, or place on your mirror so you can always see them.

happy BIRTHday!

DON'T GIVE up

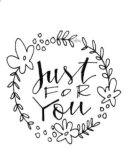

just FOR You

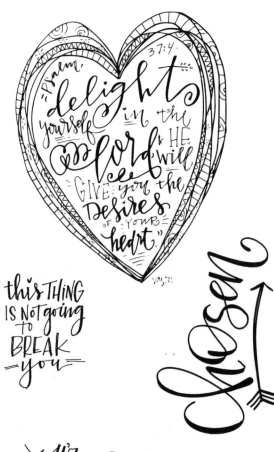

Psalm 37:4 "delight yourself in the lord & HE will GIVE you the Desires of your heart."

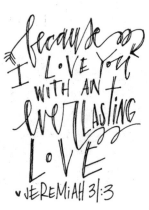

because I LOVE YOU WITH AN EVERLASTING LOVE

~ JEREMIAH 31:3

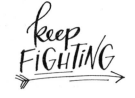

keep FIGHTING

this THING IS NOT going to BREAK you

chosen

You're enough

You're Enough

LOVE

MY FLESH & MY heart May FAIL, but GOD IS the STRENGTH of my Heart & MY PORTION forever

PSALM 73:26

FOR You formed MY inward parts; You knitted ME together in MY MOTHER'S WOMB. I PRAISE You for I AM fearfully AND WONDERFULLY made. wonderful are YOUR WORKS; my SOUL KNOWS it very well. PSALM 139

you are SUPER Beautiful

Enlarge, cut out, and put these mirror cards on fun-colored paper with washi.

happy BiRTHday!

because I LOVE YOU WITH AN everlasting LOVE
JEREMiAH 3|:3

You're enough

MY FLESH & MY heart may FAIL, but GOD IS the STRENGTH of my Heart & MY PORTioN forever
psaLM 73:26

FOR You formed MY inward parts; You knitted ME together in MY MotHer's WoMB. I PRAISE You for I AM fearfully AND WoNDERFULLY made. wonderful are YoUR WORKS; my SOUL KNOWS it very well. PSALM 139

you are SUPER Beautiful

BE BRAVE

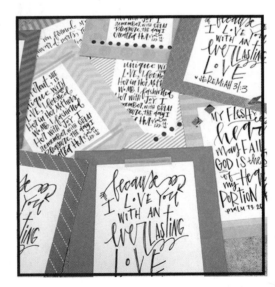

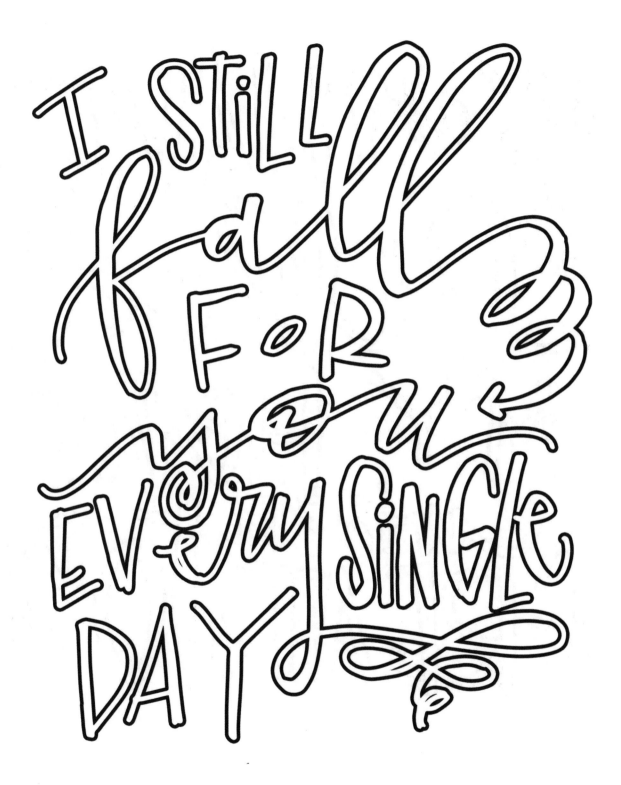

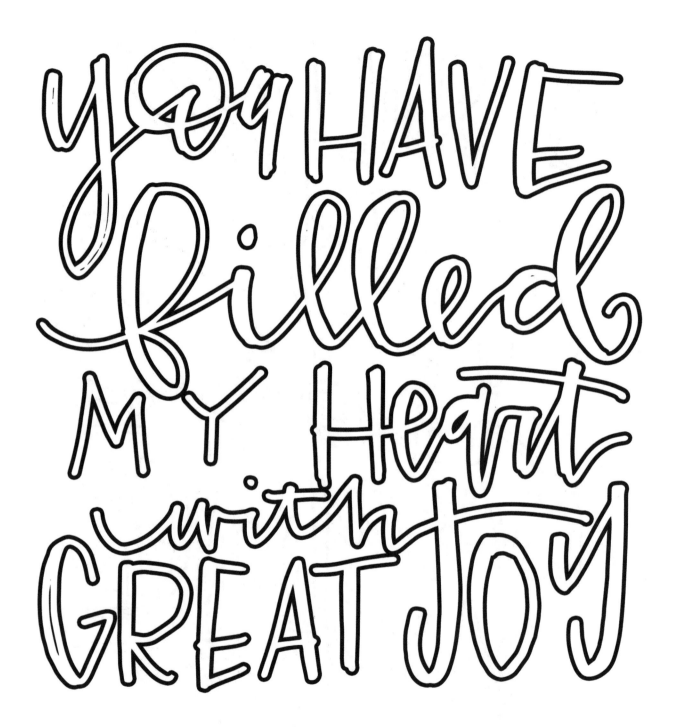

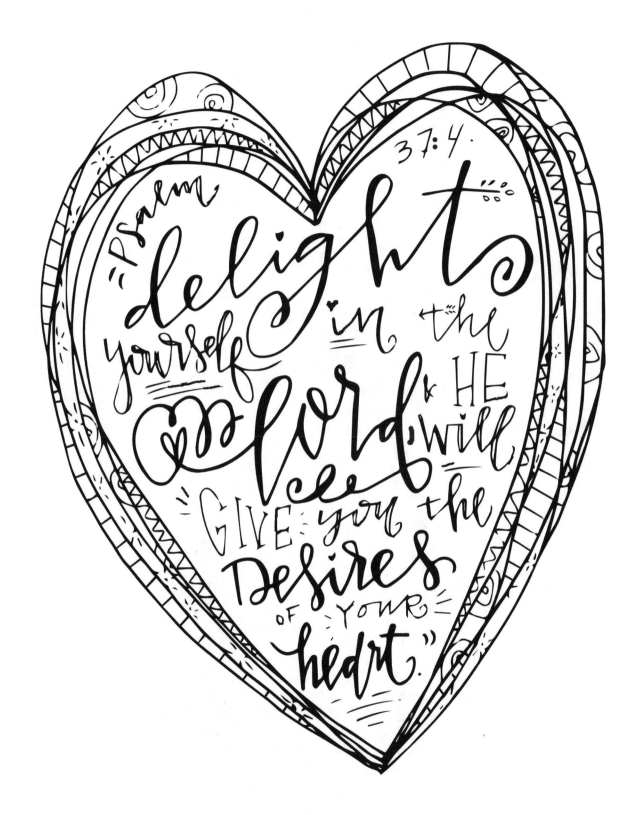

Psalm 37:4

"delight yourself in the Lord & He will give you the desires of your heart."

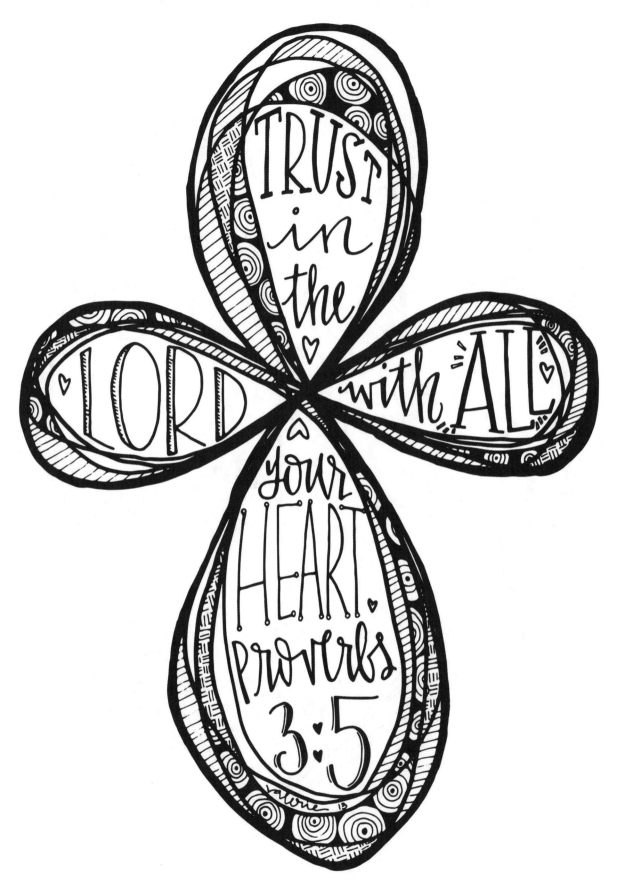

TRUST in the LORD with ALL your HEART. Proverbs 3:5

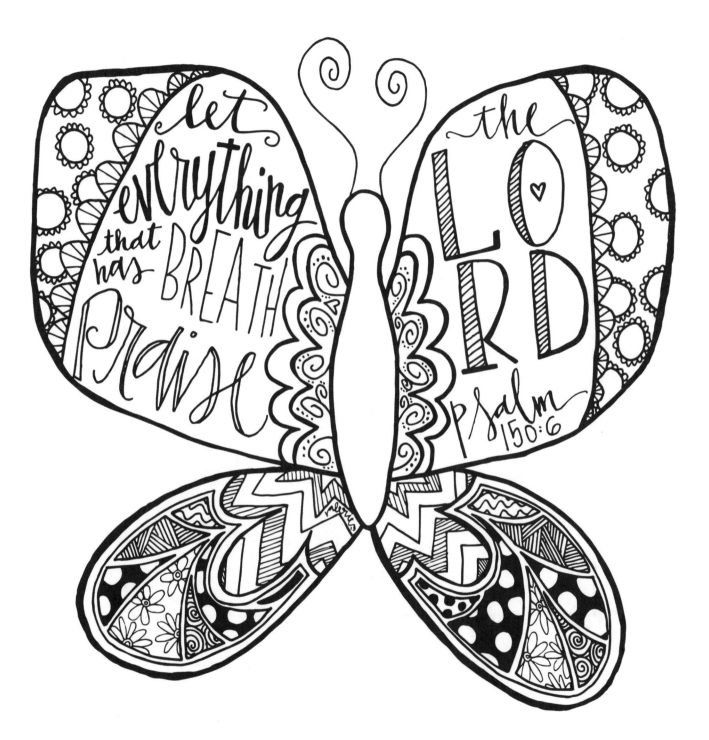

let everything that has breath praise

the LORD

psalm 150:6

Use this template to create your own piece of framable art with
lettering. Once you're finished, this will fit in a 5"x7" frame.

Use this template to create your own piece of framable art with lettering. Once you're finished, this will fit in a 5"x7" frame.

Use this template to create your own piece of framable art with lettering. Once you're finished, this will fit in a 5"x7" frame.

Use this template to create your own piece of framable art with lettering. Once you're finished, this will fit in a 5"x7" frame.

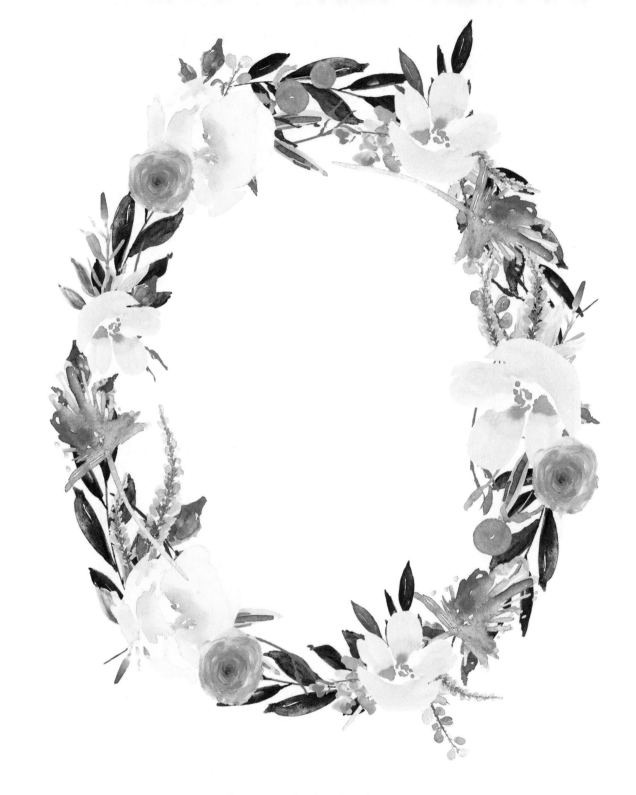

Letter inside this floral wreath.

Use a white gel pen to letter on this page.

About the Author

Valerie lives in Amarillo, Texas, with her husband, Brad; her son, Oliver; and her overweight teacup Chihuahua named Taylor. She loves everything about the art of drawing letters and loves to encourage others to believe in themselves. Valerie has a passion for people recovering from drug or alcohol abuse and eating disorders because she knows just how hard it is to get out of that life. Valerie loves Jesus and hopes that it is evident in all she does.

Follow more of Valerie's story and see clips of her everyday life on Instagram @valeriewieners and Facebook @Valerie Wieners Art.

Check out Valerie's online shop at www.valeriewienersart.com.

Most CHARISMA HOUSE BOOK GROUP products are available at special quantity discounts for bulk purchase for sales promotions, premiums, fund-raising, and educational needs. For details, write Charisma House Book Group, 600 Rinehart Road, Lake Mary, Florida 32746, or telephone (407) 333-0600.

THE ART OF WORDS by Valerie Wieners
Published by Passio
Charisma Media/Charisma House Book Group
600 Rinehart Road
Lake Mary, Florida 32746
www.charismahouse.com

Scripture quotations are primarily taken from the Modern English Version. Copyright © 2014 by Military Bible Association. Used by permission. All rights reserved.

Other scripture quotations are either adapted and paraphrased by the author or taken from one of the following versions:

The Darby Translation of the Bible. Public domain.

The Holy Bible, English Standard Version. Copyright © 2001 by Crossway Bibles, a division of Good News Publishers. Used by permission.

King James 2000. Copyright © 2001, Robert A. and Thelma J. Couric.

Lexham English Bible. Copyright 2012 © Logos Bible Software. Lexham is a registered trademark of Logos Bible Software.

The Holy Bible, New International Version®, NIV®. Copyright © 1973, 1978, 1984, 2011 by Biblica, Inc.™ Used by permission of Zondervan. All rights reserved worldwide. www.zondervan.com. The "NIV" and "New International Version" are trademarks registered in the United States Patent and Trademark Office by Biblica, Inc.™

The New King James Version®. Copyright © 1982 by Thomas Nelson. Used by permission. All rights reserved.

The Holy Bible, New Living Translation, copyright © 1996, 2004, 2007. Used by permission of Tyndale House Publishers, Inc., Wheaton, IL 60189. All rights reserved.

Cover illustration by Valerie Wieners
Cover design by Lisa Rae McClure
Design Director: Justin Evans

Visit the author's website at www.valeriewienersart.com.

Library of Congress Cataloging-in-Publication Data:
An application to register this book for cataloging has been submitted to the Library of Congress.
International Standard Book Number: 978-1-62999-156-6

While the author has made every effort to provide accurate Internet addresses at the time of publication, neither the publisher nor the author assumes any responsibility for errors or for changes that occur after publication.

All products and company names are suggestions from the author; this does not imply endorsement by them or affiliation with them.

17 18 19 20 21 — 987654321
Printed in the United States of America